Great Modern Masters

Johns

General Editor: José María Faerna

Translated from the Spanish by Alberto Curotto

CAMEO/ABRAMS

HARRY N. ABRAMS, INC., PUBLISHER

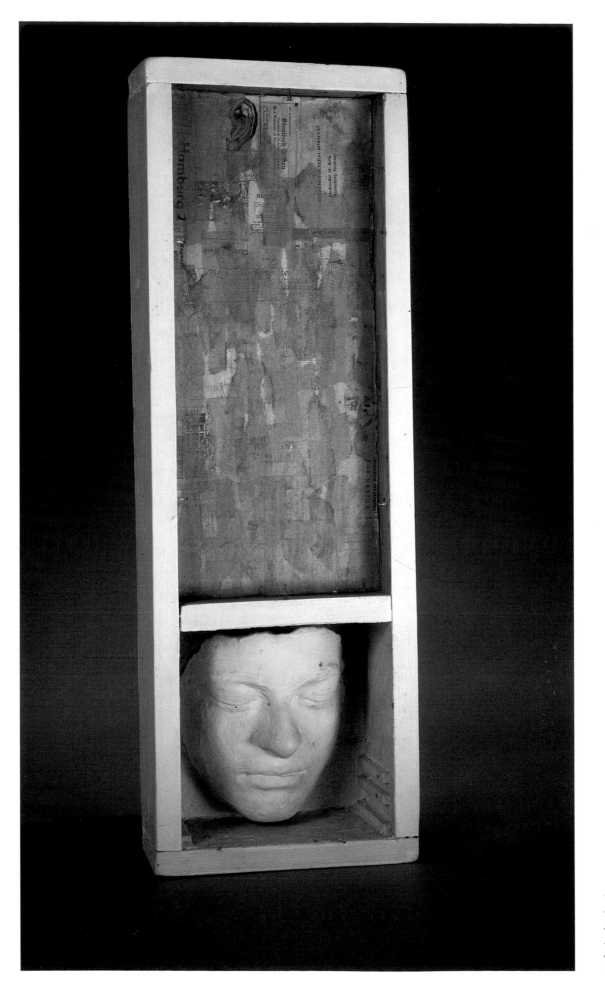

Untitled, 1954. Painted wood, plaster, and collage, 26 × 8″ (66 × 20.3 cm). Hirshhorn Museum and Sculpture Garden, Washington, D.C.

Jasper Johns. Painting and the Object

After the end of World War II, as the art world's gravitational center shifted to New York, the American scene was dominated by Abstract Expressionism. This label designates a group of very different artists who, although united by abstraction and a preference for large formats, often displayed quite diverse painterly aims. Almost all of the Abstract Expressionists matured between 1947 and 1950. In the early 1960s, the artistic landscape was radically changed by the emergence of Pop art, which focused on the objects and images of mass culture. Between these two generations, especially in the second half of the 1950s, a number of artists paved the way for Pop art. The two most important of these were Robert Rauschenberg and Jasper Johns. Both were affiliated from the very beginning with the art dealer Leo Castelli, who was to become one of the chief promoters of the Pop movement.

Targets and Flags

The significance of Johns's work, however, cannot be reduced simply to its role as a link between the two movements, for Johns is unquestionably one of the most important American painters of our century. When he painted his first targets and flags—undoubtedly the best known themes in his repertoire—not only was he foreshadowing Pop art's renewed interest in the object as motif, he was shaping a totally unprecedented discourse on the relationship between images and their representation. In traditional representational art, a painting is unequivocally distinct from the thing it represents, be it one or more objects, the human figure, or anything else. This difference is much less clear in Jasper Johns's work, especially in the case of his targets and flags. Occupying the painted surface in its entirety, these motifs become one and the same with it, so that the viewer does not have the impression of seeing a painting that represents a flag or a target, but rather a flag or a target made of paint: the painting is a flag, and the flag is a painting.

Paradoxical Relations

Johns has always emphasized the painterly nature of his images, and he has availed himself of every conventional technical resource, including textural variations, primers, varnishes, accentuated brushwork, and gestural forms. On occasion, by writing the names of the colors on the painting, he has even stressed the old notion that a painting is a sequence of colors arranged according to a predetermined scheme. By setting painting and object in such an ambiguous terrain, Johns's work elicits, even beyond the artist's own intention, deep speculation regarding the nature of painting as a medium of representation and of the object as a repre-

A characteristic image of the artist, photographed by Hans Namuth in 1988.

John Cage introduced Johns to the New York art scene and to many of its protagonists, who would later influence the painter's professional development.

The work of Marcel Duchamp (above) strongly affected Johns.

Edvard Munch. Self-Portrait Between the Clock and the Bed, 1940–1942. Johns drew inspiration from this work for three canvases that he painted in 1981–1983.

Robert Rauschenberg (above) and Johns best exemplify the transition between Abstract Expressionism and Pop art.

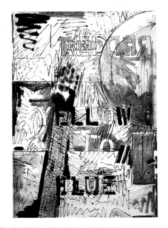

The End of the World, 1978. *Johns's graphic output consisted chiefly of silk-screens and lithographs, although in some instances he executed etchings such as this one.*

sentable element. The relations between the distinctive terms of the painterly idiom—motif and representation, space and surface, form and color—become paradoxical and problematic: they lose the smug stability of well-established categories that they used to hold in the viewer's mind. The artist took one further step in this direction when, in 1958, he began to incorporate real objects into his paintings. These objects never pre-empt his painting completely, as they do in the works of his friend Robert Rauschenberg, who had preceded him in this type of inquiry. Johns has maintained his primary loyalty to painting throughout his career, and although his pieces sometimes include brooms, cans, brushes, or embossed letters, we nevertheless continue to view them as paintings. We should not forget, however, that before 1955 much of his production was reliefs and casts, and that his interest in the material world has led him to cast everyday objects in bronze, which he subsequently painted.

Intrinsic Significance

Such approaches were at times misinterpreted. When Johns's and Rauschenberg's work first became known in Europe, between the late 1950s and early 1960s, the flags raised some eyebrows. "Please, my dear, absolutely no flags!" was the comment that a French critic, fearful of nationalistic interpretations, made to the American gallery owner who first showed Johns's work in Paris. He and others had failed to understand that Johns's interest in flags, targets, numbers, and letters lay in the iconic nature of formalized and readily recognizable images. Inasmuch as they are ideal representations of concepts, they are essentially abstract images. Their thematic value is no greater than that of the facade of Rouen cathedral in Monet's work, as the gallery owner pertinently put it in his sensible rejection of his French friend's advice. One should not forget, however, that the effect of these paintings is rooted in those images' peculiarly intrinsic significance, which does not cease, even after their transformation into paintings.

A Living Modernity

The latter paradox links such works to the Dadaist and Surrealist legacy of ready-mades, especially when the paintings incorporate external objects. At the time, some European critics went so far as to brand Johns and Rauschenberg as neo-Dadaists. Although eventually that characterization proved mistaken, it led Johns, according to his own statement, to take an interest in the work of Marcel Duchamp, which was destined to become a fruitful influence on him. Nowadays, Johns's work fetches higher prices than that of any other living artist. Such extraordinary success stems not only from his work's exceptional quality, but also from the fact that it constitutes a juncture of modern traditions: from the conceptualism of Duchamp and the Dadaists to the inquiries of the Cubists and other early avant-garde artists into the problem of representation, to the postwar abstractionist rediscovery of the pictorial surface, to Pop art's rehabilitation of the object. Moreover, Johns is a genuine virtuoso; his technical ability is evident even for a viewer who may not be quite accustomed to modern taste. His oeuvre is a safe-conduct for painting on the unsettled stage of contemporary art.

Jasper Johns

Jasper Johns is a reticent man, jealous of his privacy, and only little is known of his life before he became an established artist. He was born in 1930 in the heart of the Deep South, in Augusta, Georgia. After his parents' divorce, he was raised by aunts, uncles, and grandparents in Allendale and elsewhere in South Carolina. He went to college in the South, but as early as 1949 moved to New York and enrolled in a school of commercial arts. After enlisting in the army, he was stationed in Japan, where he remained until 1952. The few tenuous traces of Japanese derivation that some of his later works display, however, are due not to his firsthand experience of that civilization, but to his long-standing friendship with musician John Cage, one of the central figures of the American avant-garde, whose interest in Zen Buddhism is well known.

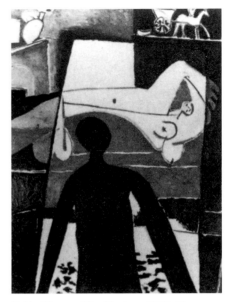

Pablo Picasso. The Shadow, *1953. The importance of the silhouette in the* Four Seasons *series, exhibited at the 1988 Venice Biennale, may have originated from this work by Picasso.*

Manhattan Store Windows

We do not know much of Johns's first steps as an artist, since he has apparently destroyed all his early works. In 1954, he met Robert Rauschenberg and John Cage, both his elders. While Rauschenberg was destined to become Johns's inseparable companion throughout their parallel artistic trajectories, Cage also exerted a gradual and discreet influence on him, besides introducing him to some of the foremost figures of the New York and international art world, such as the choreographer Merce Cunningham and the Dada master Marcel Duchamp. Johns and Rauschenberg settled in nearby studios in downtown Manhattan, and both made their living as store window designers. In the mid-Fifties, their respective careers were finally taking shape. In 1955, Jasper Johns painted his first flag, a large white panel wholly dominated by the presence of the Stars and Stripes. The dense and eminently tactile texture of this painting was obtained by means of encaustic, a technique that Johns reclaimed from Classical antiquity that calls for a mixture of hot wax and pigments. This medium is as typical of Johns's work as the characteristic themes—targets and numbers—that came to the fore at the same time. There is a clear parallel between his evolution and that of Rauschenberg; many critics have cited Rauschenberg's 1949 *White Paintings with Numbers* as a precedent for Johns's own numerical series. The two artists' closeness in those years supports such a hypothesis.

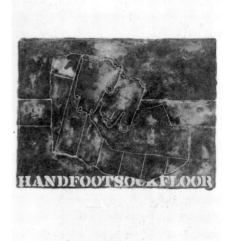

Hand/Foot/Sock/Floor, *1974. In this lithograph Johns used stenciled letters to clarify the graphic content of the image.*

Appended Objects

Three years later, in 1958, Johns's canvases began to incorporate physical objects. Once again the painter was following in his friend's steps, albeit with a somewhat different intent. The objects that Johns used in his paintings always fit into a framework of essentially painterly relations, ruled by principles of texture and chromatic contrast. Rauschenberg incorporated objects much as the Dadaists had thirty years earlier, whereas Johns's work is closer to Cubist collages. Whether using *objets-trouvés* or sten-

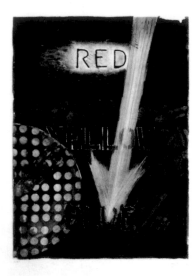

ciled words and letters—another technique of Cubist derivation—Johns works them all thoroughly into painting, an artistic discipline whose boundaries he has always tried to expand as far as possible, while keeping within its limits. In this adherence to painting and painterliness, the heritage of the of Abstract Expressionists—Pollock, Rothko, Hofmann—is very clear.

The Doors of Pop Art

Having found his own artistic orientation, Johns did not have to wait long before his career was fully launched. In 1957, he participated in a group show at the Jewish Museum in New York. The same year, he met Leo Castelli, who a year later would organize the artist's first solo exhibition at his gallery, with which Johns has been associated ever since. In 1958, Johns's work was shown in the American annex at the Venice Biennale, and the New York Museum of Modern Art purchased some of his paintings. In this same period, Johns began casting a number of everyday objects (*Light Bulb*, *Flashlight*) in bronze, and he became acquainted with Marcel Duchamp's work. Through John Cage he was also asked to collaborate as a set-designer for Allan Krapow's happenings and Merce Cunningham's dance compositions. In the early 1960s, already well established in the United States, Johns became increasingly known in Europe as well. In 1961, Michael Sonnabend organized a solo show of Johns's works in Paris, but it was the 1964 Venice Biennale—where Rauschenberg was awarded the first prize—that set the stage for his international repute. Both artists helped open the doors of Europe to North American art, including both Abstract Expressionism and the Pop art that was to follow.

Crosshatchings

Flags, targets, numbers, and letters dominated Johns's production until the 1970s, and he never quite relinquished them even then. *Harlem Light* (1967) is the first work in which he used the so-called flagstones, a motif that recalls an irregularly paved wall that the artist had apparently seen while looking at street graffiti. A similar inspiration perhaps led him, in 1972, to paint large surfaces entirely covered with crosshatchings, or patterns of color strokes arranged in sets of superimposed and intersecting lines, like those of canvas or cloth seen from very close range. Never before had Johns approximated absolute abstraction as closely as in these paintings, which clearly evince the influence of Pollock, to whom he paid homage with *Fragrance* (1973–1974), one of his best known crosshatchings.

In recent years, Johns has again incorporated images into his painting. The most significant example of this new trend may very well be his series *The Four Seasons* (1985–1986), which received an award at the 1988 Venice Biennale and marked the climax of his prestige as one of the foremost artists of the second half of the twentieth century. Since 1960, parallel to his painterly output, Johns has produced an important body of graphic works—mostly lithographs and silkscreens—which explore the same themes and objectives found in his painting.

Untitled (Red, Yellow, Blue), *1982. Three color etchings that reiterate some typical themes of Johns's paintings.*

Plates

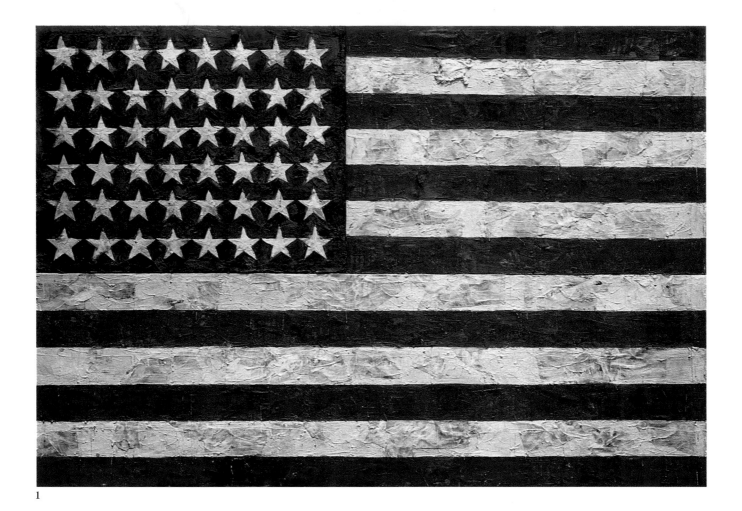

1

Stars and Stripes

The most emblematic theme of Jasper Johns's oeuvre, the one that makes it immediately identifiable, is the American flag. The earliest such works date from 1955, as do the first targets. A few years later, Johns started painting maps of the United States, with the names of the states visibly superimposed on them. While maps became increasingly sporadic and infrequent after the 1960s, flags and targets have recurred throughout his painterly and graphic production both as central themes and as quotations. Flags, targets, and maps are all instances of preexistent planar images with Dadaistic color sequences, which the painter at times reinterprets monochromatically, emphasizing the importance of texture with encaustic and collage. All three of these images are abstract, although targets are possibly more ideographic—suggesting direction and depth— while maps and flags are more representative and symbolic. In general, these images occupy the entire surface of Johns's typically large paintings to the extent of merging with them, although they sometimes appear against a colored background.

1 Flag, *1954-1955. The flag provides the painter with both a graphic and a chromatic structure. Here Johns retains the original colors, while the image's painterly nature is highlighted by its texture, obtained by means of collage and encaustic.*

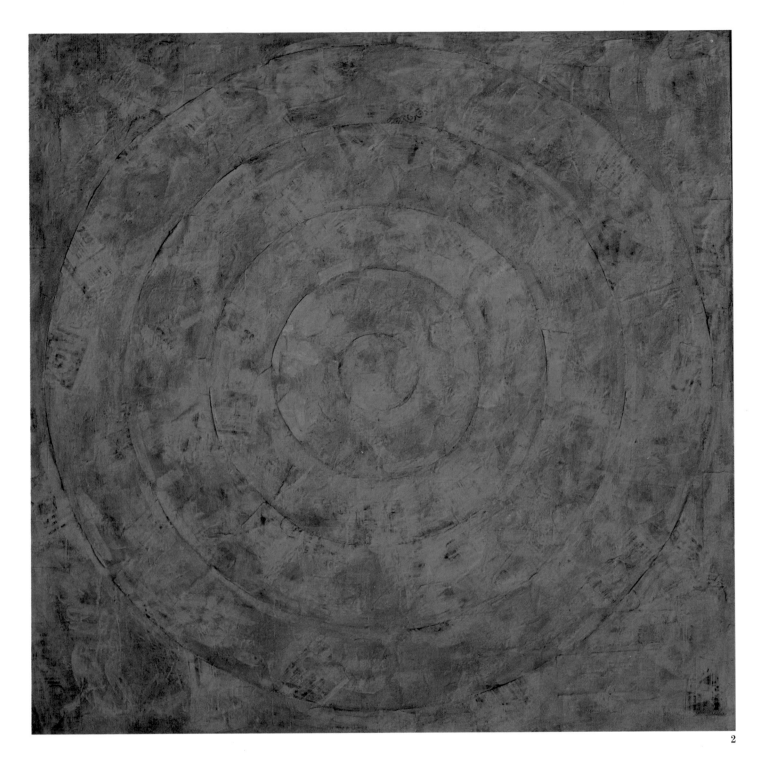

2

2 Green Target, *1955. In this monochromatic rendering, the target serves as a structural organizing principle for the pictorial surface, in an ambiguous ground halfway between representationalism and abstraction.*

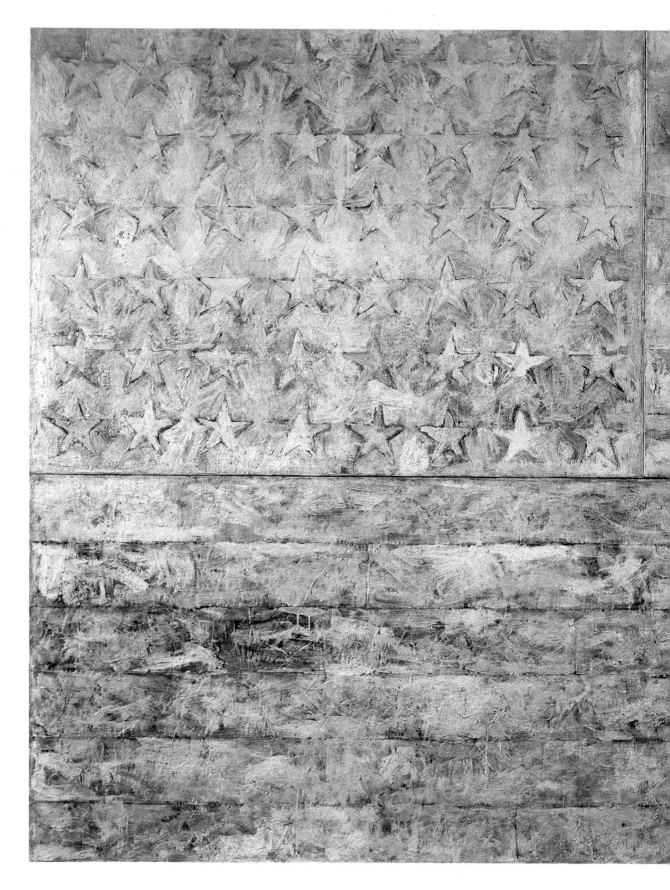

3 White Flag, *1955. Critics generally agree that this was the first flag ever painted by Johns. Its large format and monochromatic palette allow a more visible exploitation of the expressive possibilities of encaustic. Moreover, the fact that canvas and actual flags share the same textile nature adds to the formal merging of the object with the painting, possibly the most striking contribution of the artist's early work.*

3

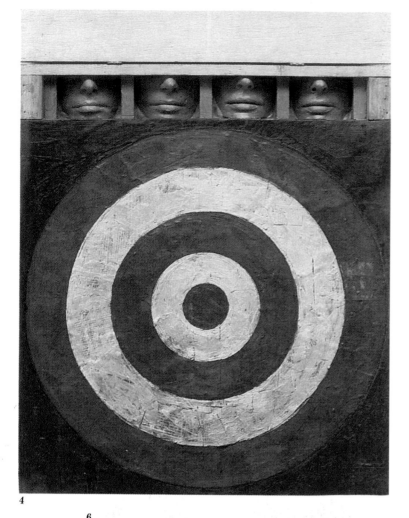

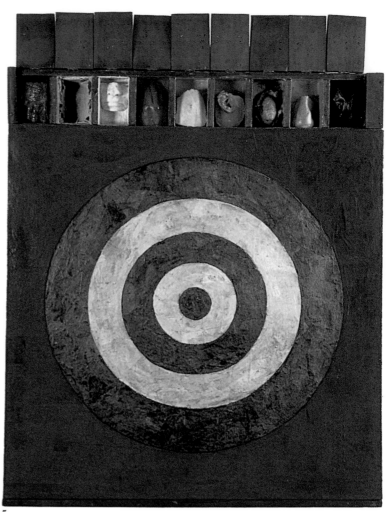

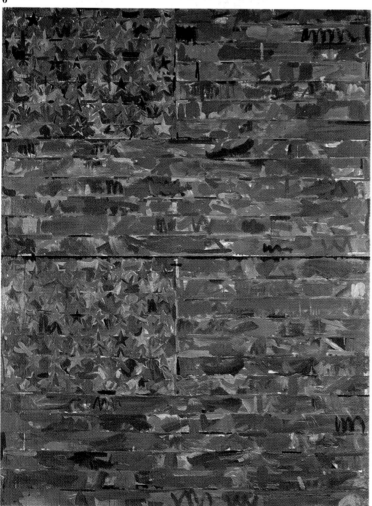

4, 5 Target with Four Faces, *1955.* Target with Plaster Casts, *1955. Like the targets, the plaster casts are more than mere representations: they are actual impressions of body parts. The parallelism between the target and the casts underpins the conceptual discourse put forth in the work.*

6 Two Flags, *1959. The duplication of the flag foreshadows the interest in serial images that will later characterize such Pop artists as Andy Warhol.*

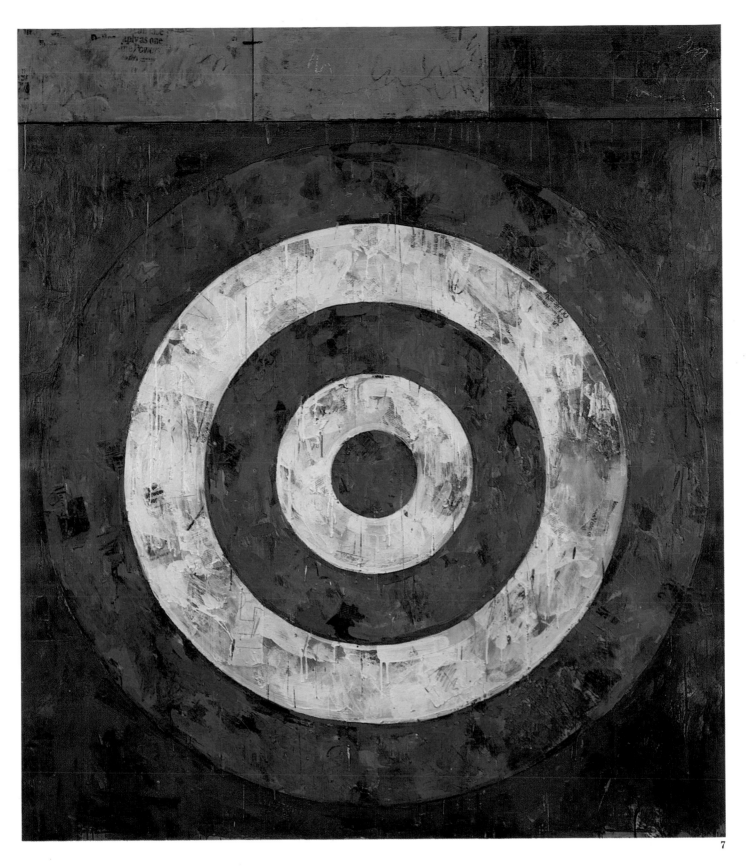

7 Target, *1974. Johns never gave up his most*
emblematic themes even in the later stages of his
career. In this example, one can readily perceive the
inclusion of scraps of paper in the paint surface, a
technique that goes back to Cubist collages.

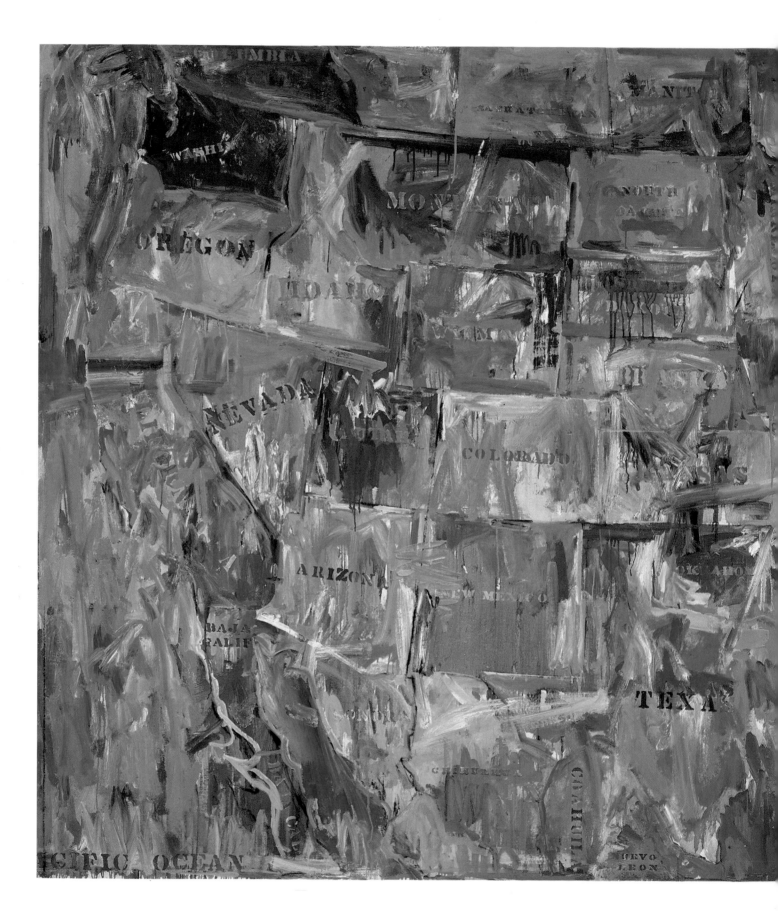

16

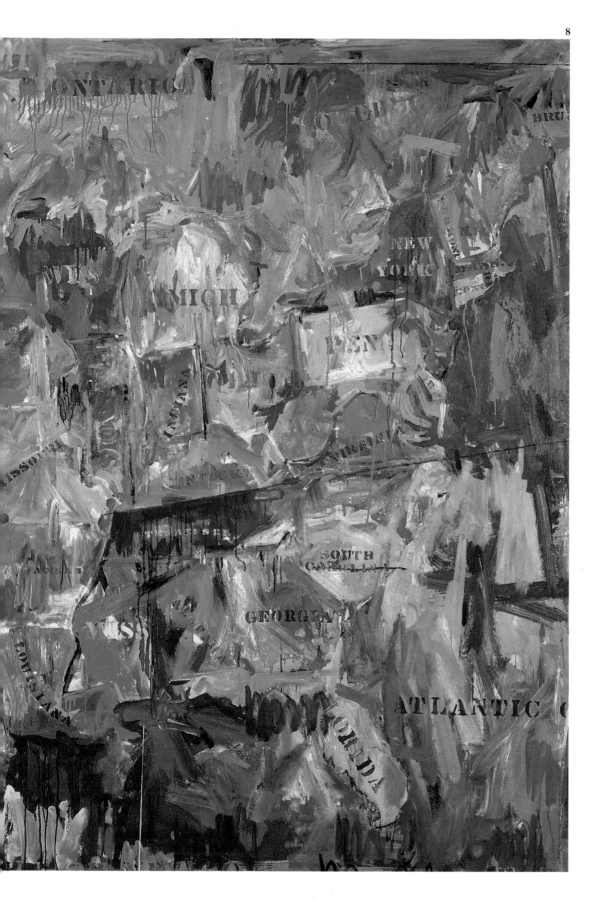

8 Map, *1961. Unlike flags and targets, maps are both objects in themselves and abstract representations of a different reality. Hence, from a conceptual standpoint, the relation between object, image, and painting becomes here increasingly complex. Johns appropriates the traditional chromatic reference of color-coded maps and translates it into terms of pictorial composition, in a liberally applied harmony of reds, blues, and yellows. The dripping technique, with its arbitrary gushes of paint, is a legacy of Abstract Expressionism.*

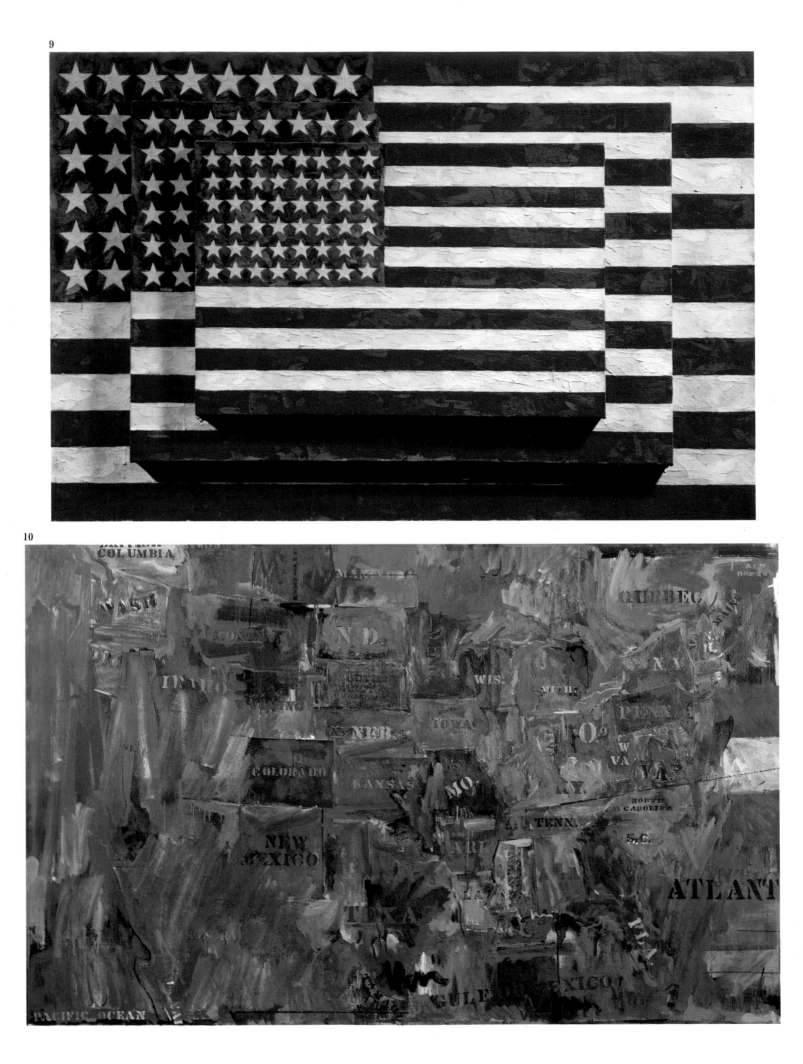

9 Three Flags, *1958. Another type of serial imagery is obtained here by varying the scale and by playing with the flatness of both flag and painting.*

10 Map, *1963. The red, yellow, and blue stripes on the right serve the same purpose as the chromatic scale often shown in photographs. The fragmentation of the map—which seems to continue beyond the boundaries of the painting—stresses the notion of the pictorial surface as a virtually limitless field that Johns derived from the Abstract Expressionists.*

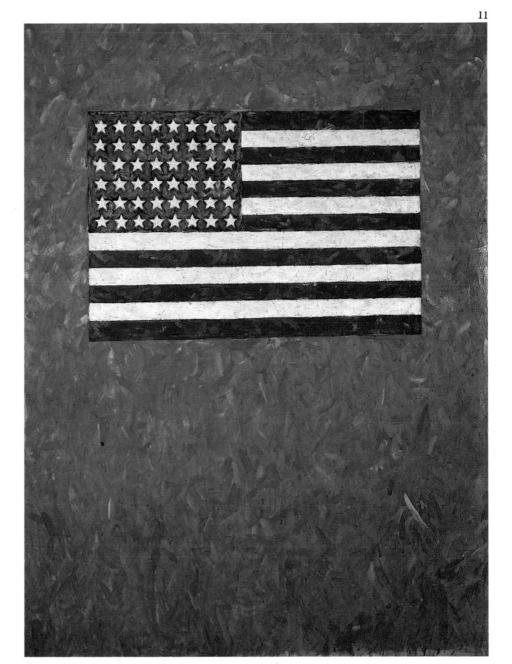

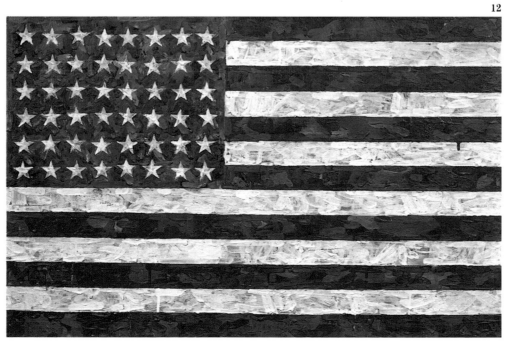

11, 12 Flag against an Orange Background, *1957.* Flag, *1960–1961. At times Johns's flags and targets are painted against a uniform colored background, another stratagem to highlight the painterly nature of the image. In the second picture, encaustic was first applied to paper, which was then pasted onto the canvas. Johns was thus able to obtain a rugged texture, less dense than when he painted directly on canvas.*

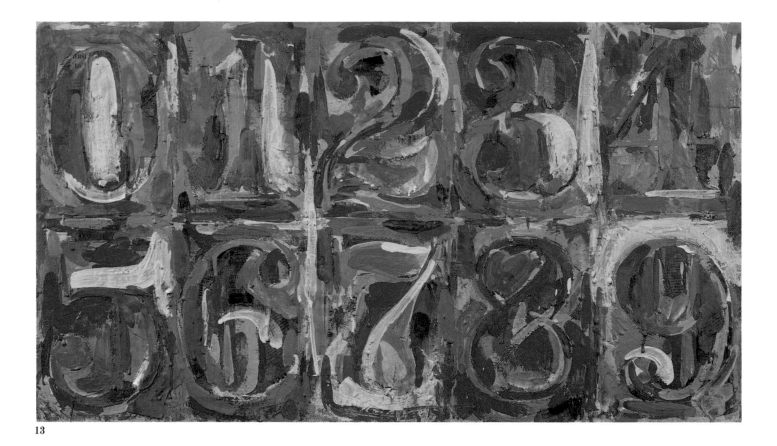

13

Numbers and Letters

Early in his career, at the same time that he was experimenting with the targets and flags, Jasper Johns also began to work in his other characteristic vein, painting numbers and letters. These may appear either isolated, as the painting's sole subject, or as part of a series. *False Start*, in 1959, was the first of many works in which the letters come together to form words variously related to the pictorial structure. Here Johns's approach is like that of the flags and targets, with some differences. Letters and numbers are abstract signs that, in the painting, are thoroughly divested of their meanings. They are reduced to graphic structures around which the painter freely organizes the pictorial surface by means of color associations, unlike the flags, which necessarily carry certain chromatic guidelines. Here there are no objects, only ideal representations whose rational nature contrasts to the vibrant and passionate pictorial matter typical of Johns's painting. When there are words, they are generally associated with sounds and meanings that interact with the painting's visual information. The composer John Cage, a close friend of the painter's, had used a similar approach in his music.

13 *0–9, 1959. The logical sequence of the numerical series enhances its ideal and abstract character. The effect of the work is determined by its painterly gestures, which acquire meaning when integrated into the iconic structure of each digit.*

14 *False Start, 1959. The title suggests a suddenly frozen chromatic explosion. The names of the colors stenciled on the canvas do not coincide with the actual colors underneath them, as if the painting were organized along two superimposed but contrasting structures. The final effect is like that of Johns's maps, albeit devoid of any concrete iconic reference.*

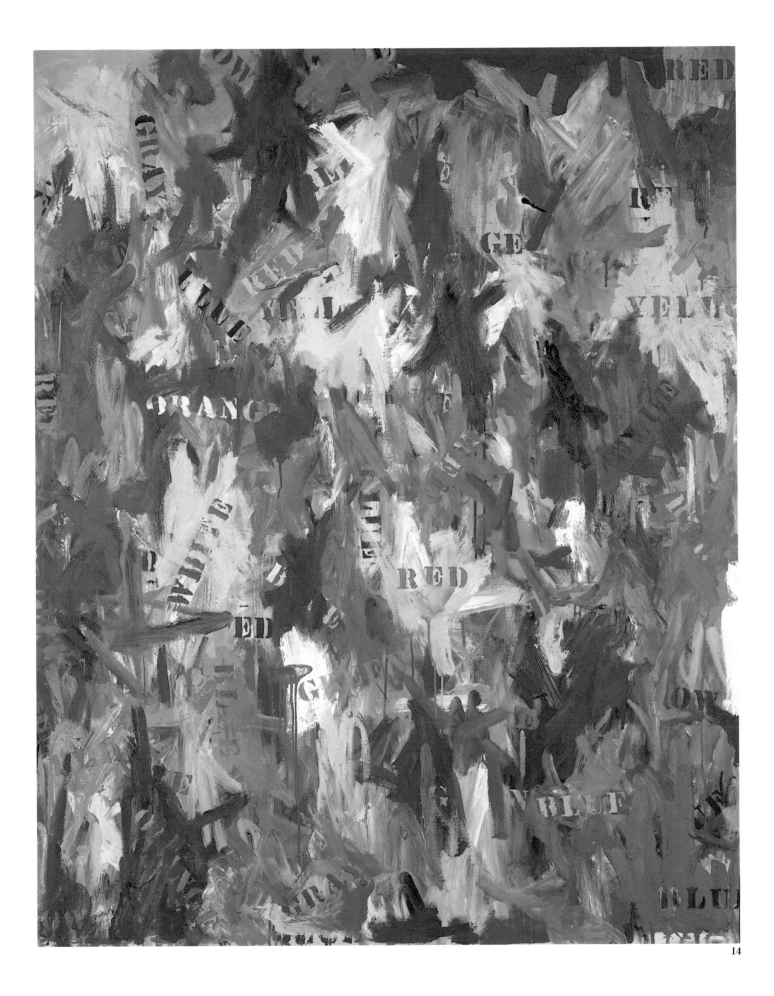

14

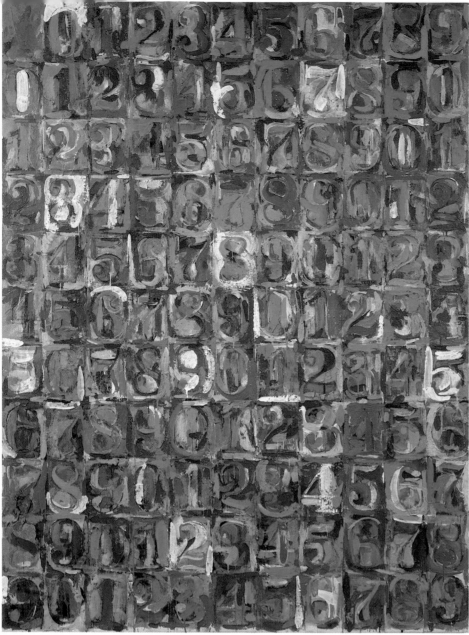

15

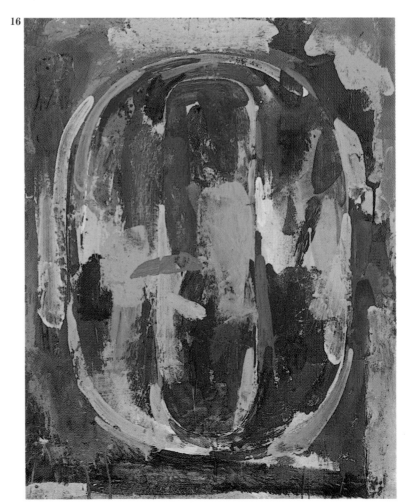

16

15 Color Numbers, *1958–1959. The strips of
numeric series make it possible to read the sequence
in any direction as if it were a table. As in a Hindu
mantra, meaning is dissolved by rhythmic
repetition, in which the numbers lose their function
and become purely formal structures.*

16 Digit 0, *1959. Zero is the most abstract of
numbers and, from a formal point of view, it
comprises all others. Johns, however, painted other
individual digits as well.*

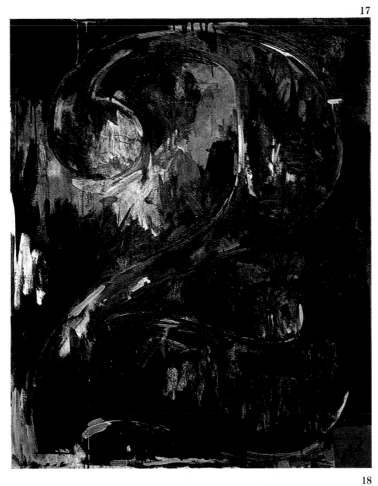

17, 18 Digit 2, *1962.* Alphabets, *1962. Although the majority of the paintings with numbers and letters from the late 1950s and early 1960s employed combinations of blue, red, and yellow, some were rendered instead in* grisaille, *as in these two examples. In* Digit 2, *moreover, the number is treated more as an outline than as the result of a painterly gesture.*

18

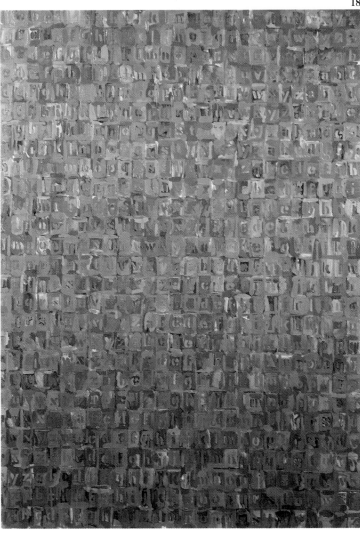

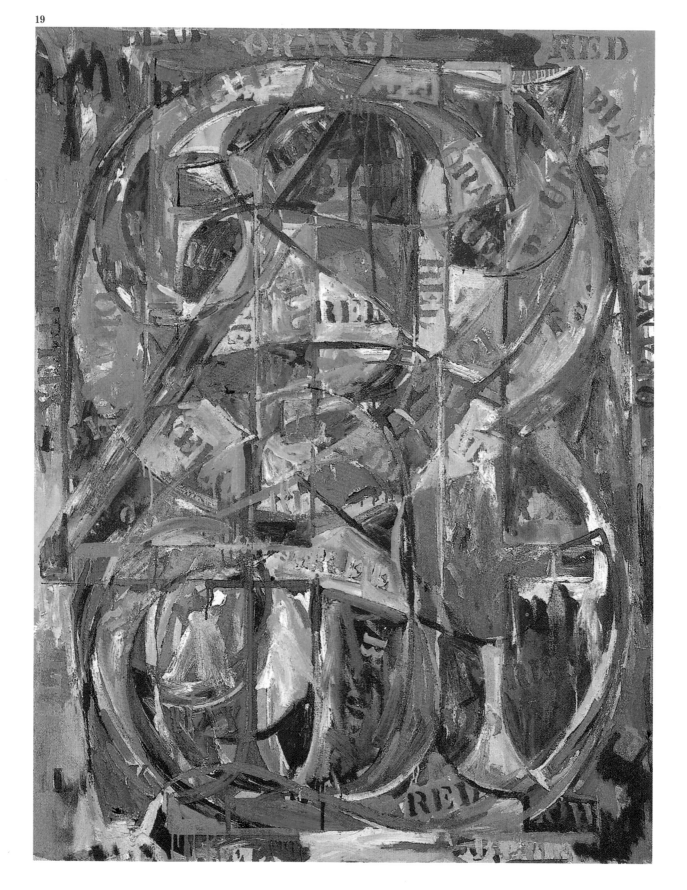

19 Zero through Nine, *1961. The superimposition of the whole numeric sequence framed by the zero causes an even greater loss of the meaning and function of the forms than in* Color Numbers *(no. 15). As in* False Start *(no. 14), Johns inscribes the names of the colors on the various blocks without any correspondence to the actual color underneath.*

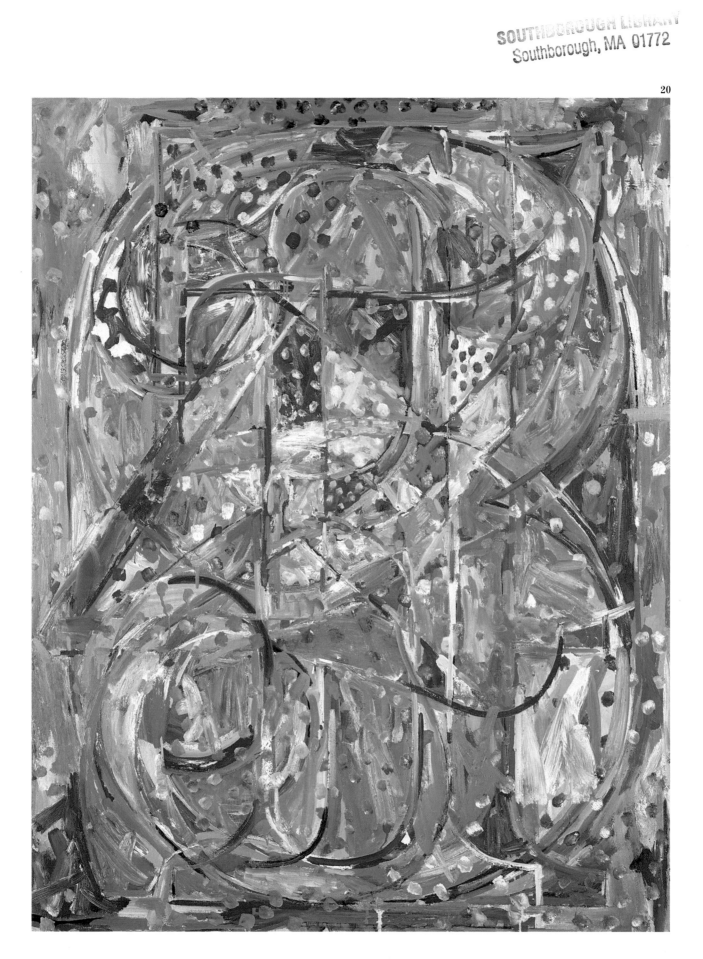

20 Zero through 9, *1961. This painting repeats the same system
as the previous one, but the names of colors have now been
replaced by polka-dots. The tonality has been made colder with
varnishes, decreasing the proportion of yellow tones and
increasing that of blue ones. Johns would later repeat this motif in
his graphic work.*

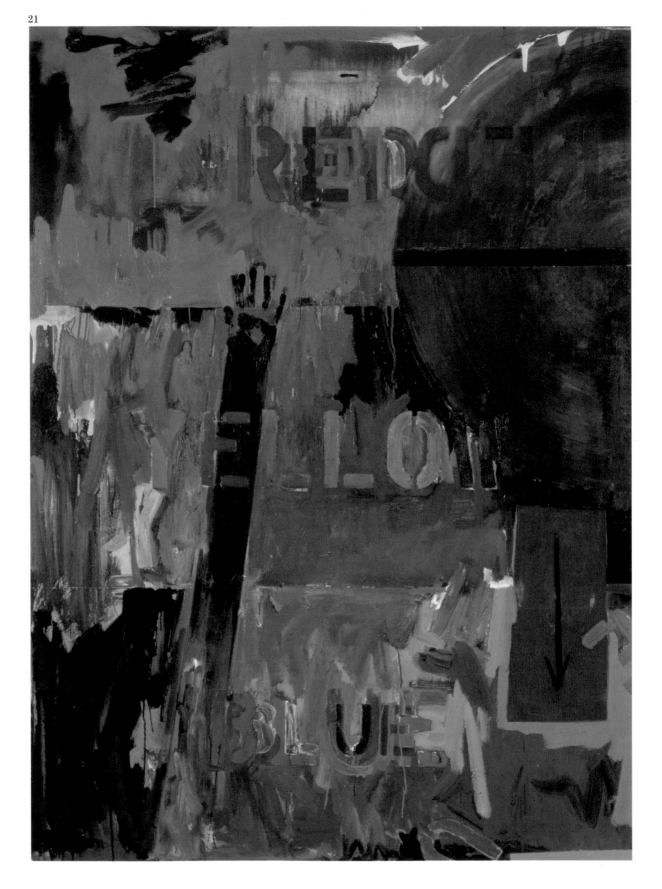

21 The End of the World, *1963. In the early 1960s, Johns reverted to compositions modulated on one single color, such as this elegant sequence of blues. The division of the surface into three stripes with the large lettered words "red," "yellow," and "blue" (the components of the basic chord of his previous paintings) was also very frequent, as were the disks and the handprints, which appear in such contemporary works as* the Divers.

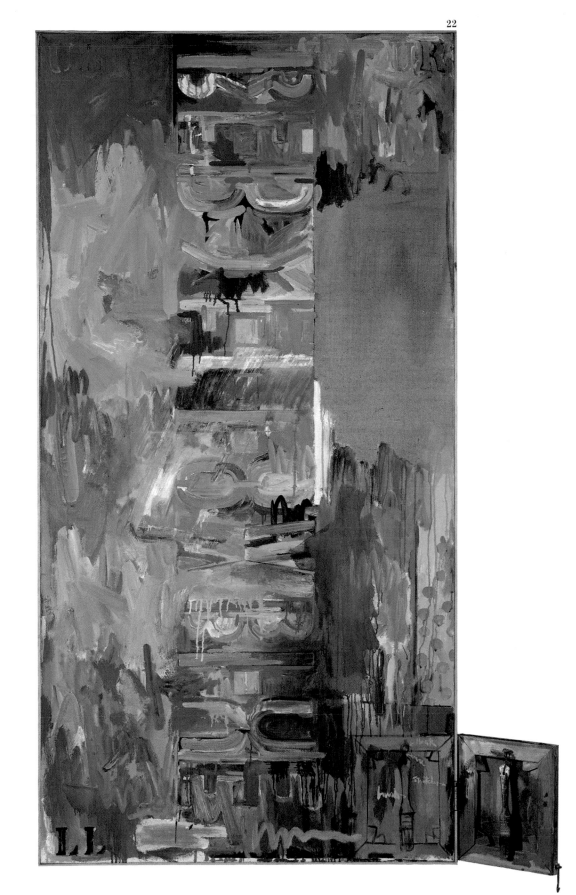

22 Slow Field, *1962. The surface is divided by a central axis of mirrored letters that seem to open like a book. The same effect is reproduced in the lower right corner, where a hinge attaches a small panel to the main image. On this panel hangs an actual brush, mirrored on the main image beside it by a painted brush, which looks as if it had been impressed on the paint surface by closing the hinged panel like a shutter. The deformation of the letters seems to be the result of their movement against the resistant density of the paint itself, a conceptual conceit also found in certain works by Duchamp.*

23 Voice 2, *1971. The overlapping letters that spell "VOICE 2" unfold across three canvases. Johns had planned to install the work as a cylinder, so as to make the viewing order of the three panels interchangeable. Because of this, some critics have surmised a relationship between this work and Philip Glass's musical scores or Robert Wilson's set designs.*

24 Fragments—According to What—Inverted "Blue," *1971. An example of the artist's use, in his graphic production, of themes and motifs that recur in his paintings.*

25, 26 Zero through 9, *1961.* Numbers, *1963–1978. Two versions, in relief on metal board, of a theme that Johns had already treated in painting.*

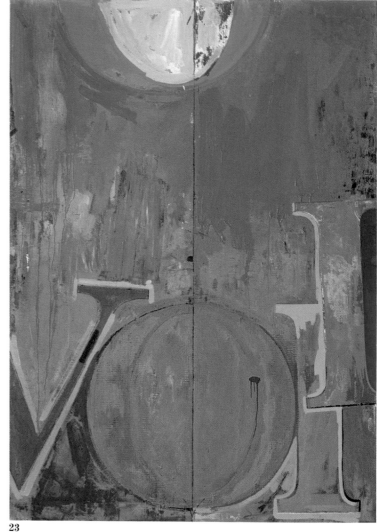

23

24

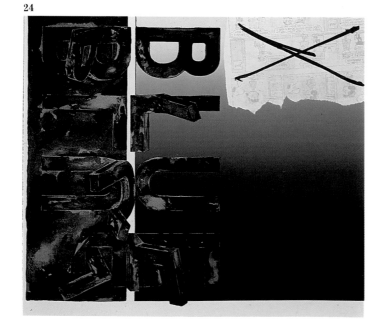

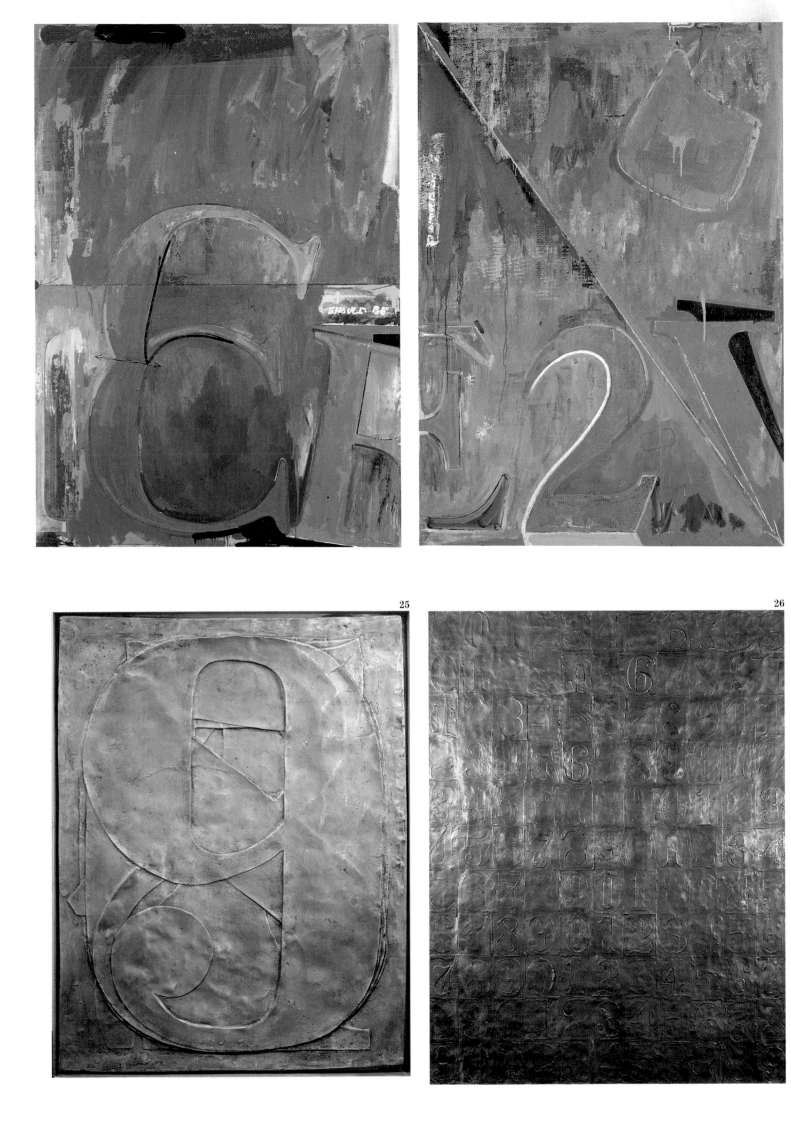

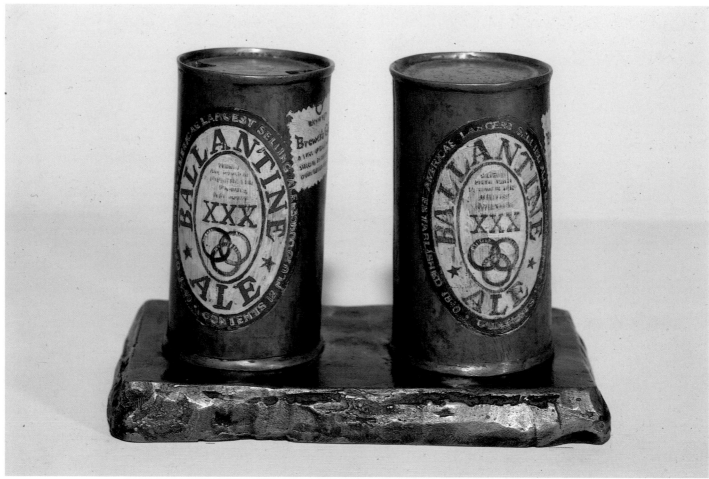

27

Painting and the Object

Jasper Johns began to incorporate three-dimensional objects in his paintings as early as 1958. As with Rauschenberg, critics immediately saw this as a legacy of Dada and Surrealism. Indeed, like his predecessors, Johns undoubtedly was trying to expand the scope of his art by relativizing the practical value of a decontextualized object; in many instances, this process also entails an ironic commentary halfway between Dada and Pop art. However, proceeding from the artist's everyday environment (brushes, cans, paint tubes), the object serves above all as a bridge between painting and experience. Unlike the flags and the targets, these objects do not supplant the painting, rather they let themselves be integrated into—or offset—its logic; in short, they take on a plastic value. Johns also made bronze castings of beer cans, light bulbs and flashlights, which he sometimes painted afterward. With these works, he most closely approximated Duchamp's ready-mades, albeit without the Dadaistic intention to challenge the status of art. "What Marcel [Duchamp] considered negative has become positive in my work," said Johns, who insisted on viewing Duchamp's oeuvre as art rather than an expression of anti-art.

27 Painted Bronze, *1960. By casting everyday objects—like these two beer cans—in bronze, the artist introduces a paradox: the copy, made as an art object, has greater commercial value than the original. This ironic wink at art and reality is a clear precedent for Andy Warhol's Campbell soup cans.*

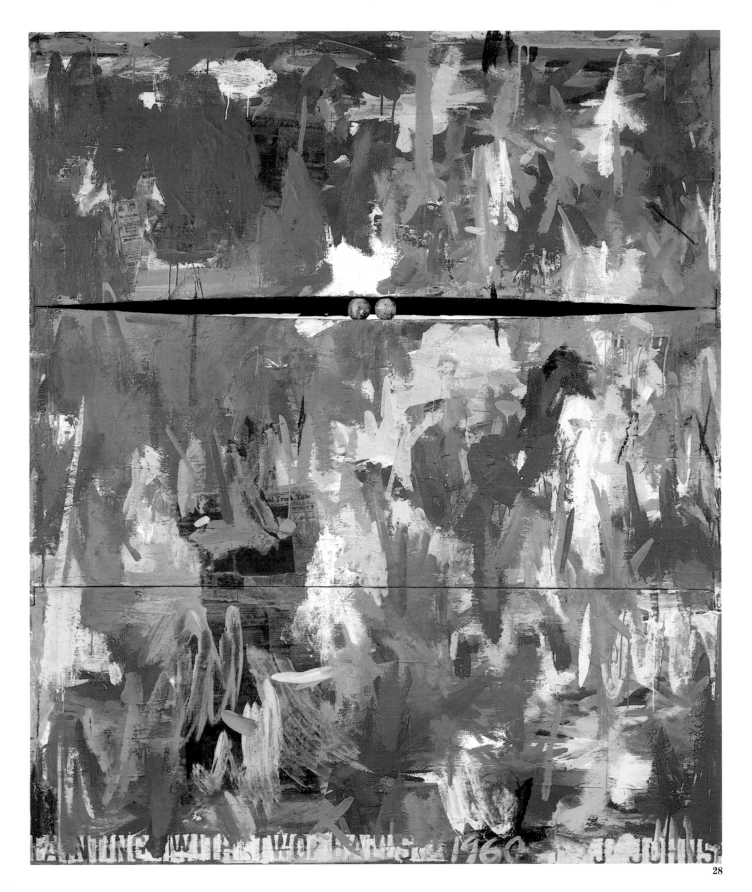

28 Painting with Two Balls, *1960. A classic example of the subordination of the object to the demands of painting. Holding open a breach in the surface, two balls cause it to warp slightly, creating stress, and adding a new dimension to an explosion of colors reminiscent of* False Start *(no. 14). This device, which suggests the ripped canvases of the conceptual artist Lucio Fontana, introduces a spatial component to the painting.*

29

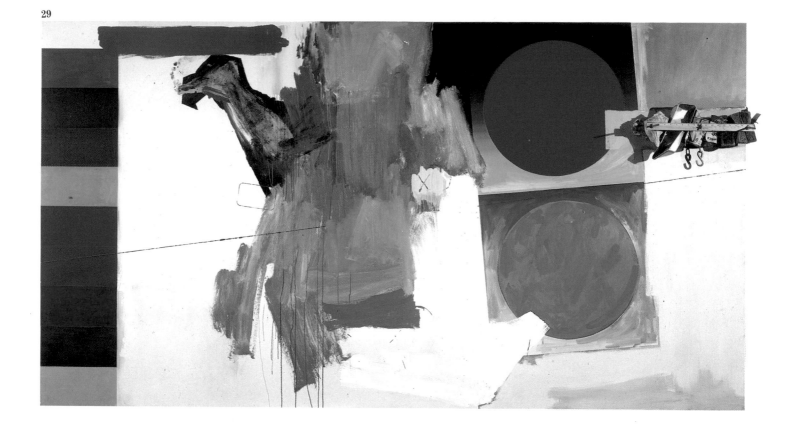

30

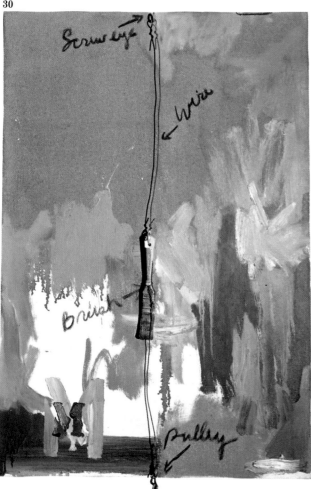

29 Eddingsville, *1965. The entire composition appears to be a play on light. The center is dominated by irregular areas of blue set against a white ground, flanked on the left by a chromatic scale, and on the right by two red and green disks inscribed in yellow and blue squares. The objects attached to the canvas on the right cast shadows on the surface, in an ironic quotation of the trompe-l'oeil motifs in certain Cubist collages.*

30 M, *1962. The brush hanging on the canvas seems to be trapped in the painting—its colors are identical to those of the background—while the blue smudge under it suggests the swinging motion of the brush over the surface.*

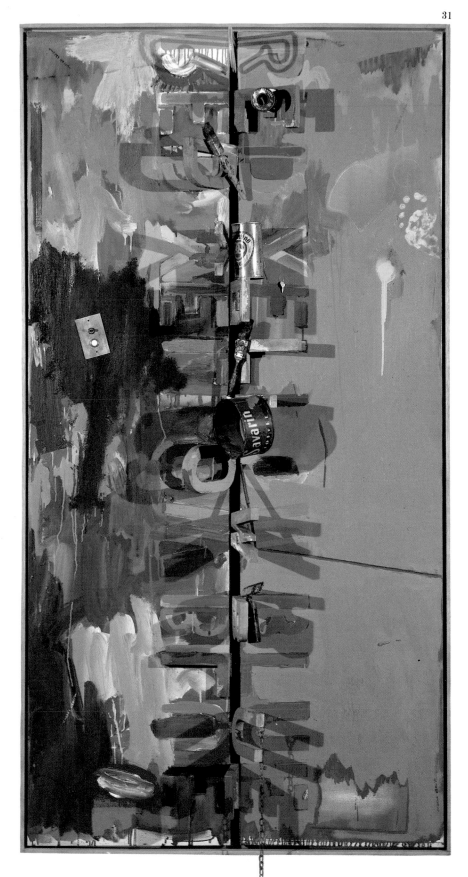

31 Painted Background, *1963–1964. Like* Slow Field *(no. 21), this painting is split along the middle, but here the fissure is real, and three-dimensional painted letters rise above it, signaling Johns's emblematic chord "RED-YELLOW-BLUE." A series of objects—beer cans, a brush, a tube, and cans of paint—cling to the central axis as if they were drawn to it by a mysterious gravitational pull.*

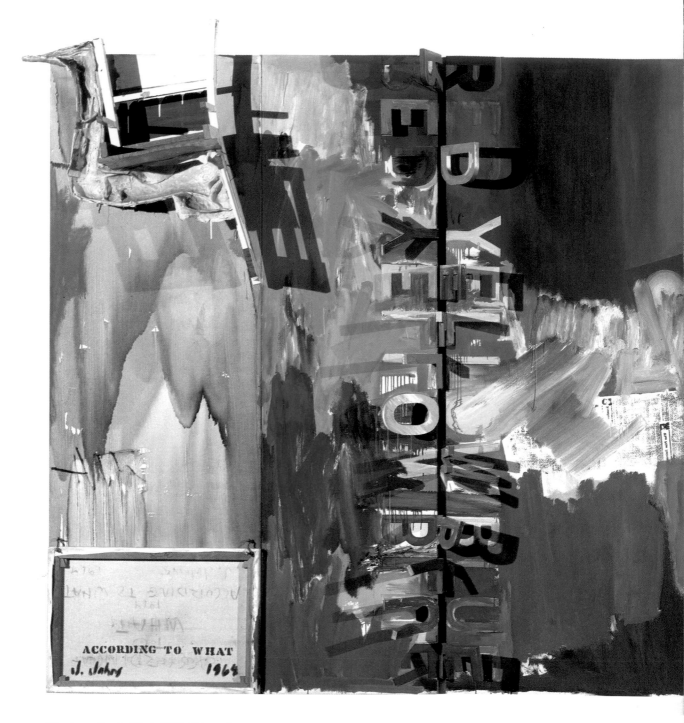

32 According to What, *1964. Yet another fundamental painting in Johns's oeuvre, in which he repeats motifs from his earlier works. The left panel is a variation on* Slow Field *(no. 22) and* Painted Background *(no. 31), with the addition of an upside-down chair. At the center a chromatic scale, and on the right a colored surface are polarized around Johns's three characteristic colors—red, yellow, and blue—whose names appear on the left. A newsprint collage extends across the diagonal, linking the different parts of the composition. This work has been compared to Marcel Duchamp's* Tu m' . . . , *which gathers recurrent themes from that artist's oeuvre over one large surface.*

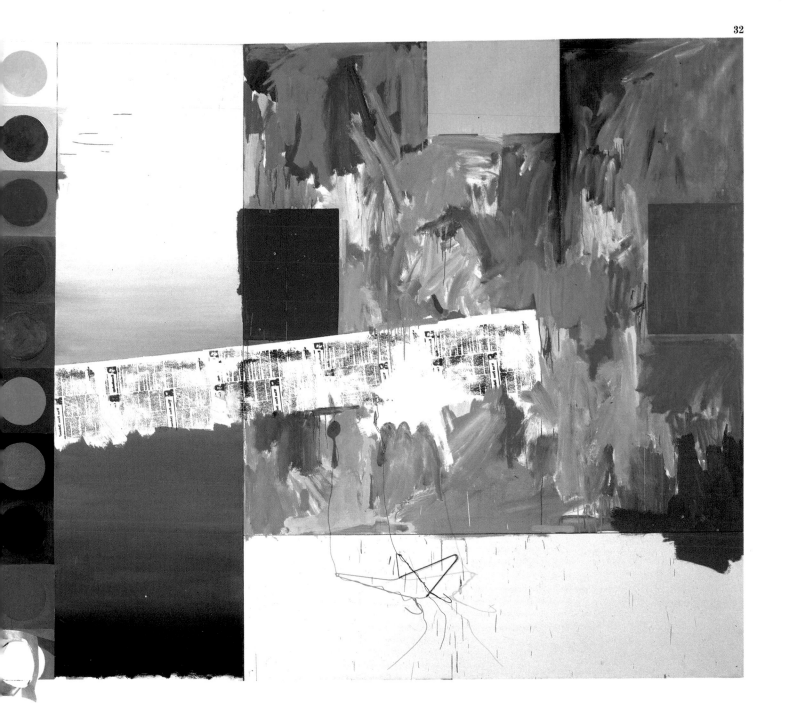

33 Zone, *1962. The objects that Johns incorporated into this painting seem to be hanging parallel to the painted surface. Thus they appear to be transient elements participating both in the painting and in reality. Such ambiguity is reminiscent of Cubist collages.*

33

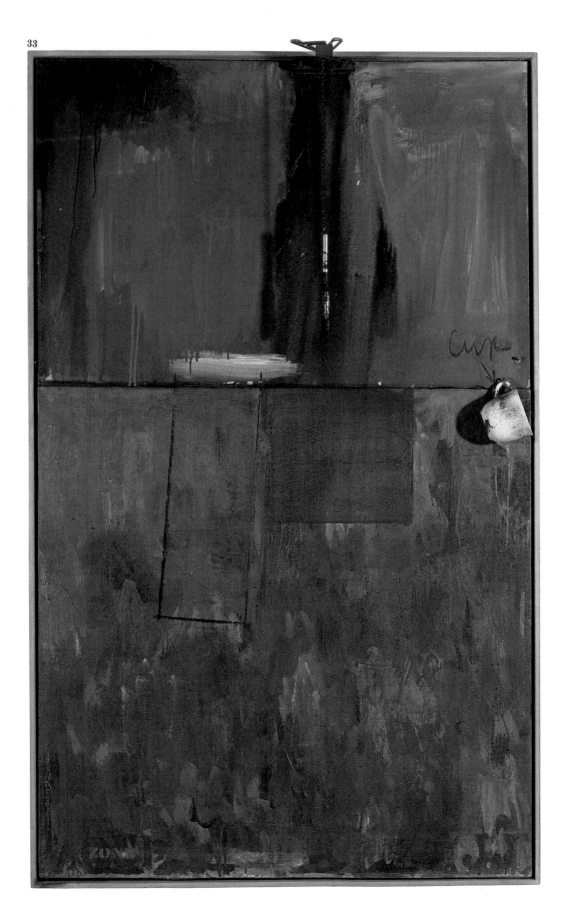

34 Device, *1961–1962. Two bars are secured to the edges of the canvas, and their apparent spinning movement seems to have generated the two symmetrical disks on the paint surface, which is harmonized in Johns's customary chord of red, yellow, and blue. Thus the artist suggests the modification of the paint structure by objects that are alien to it.*

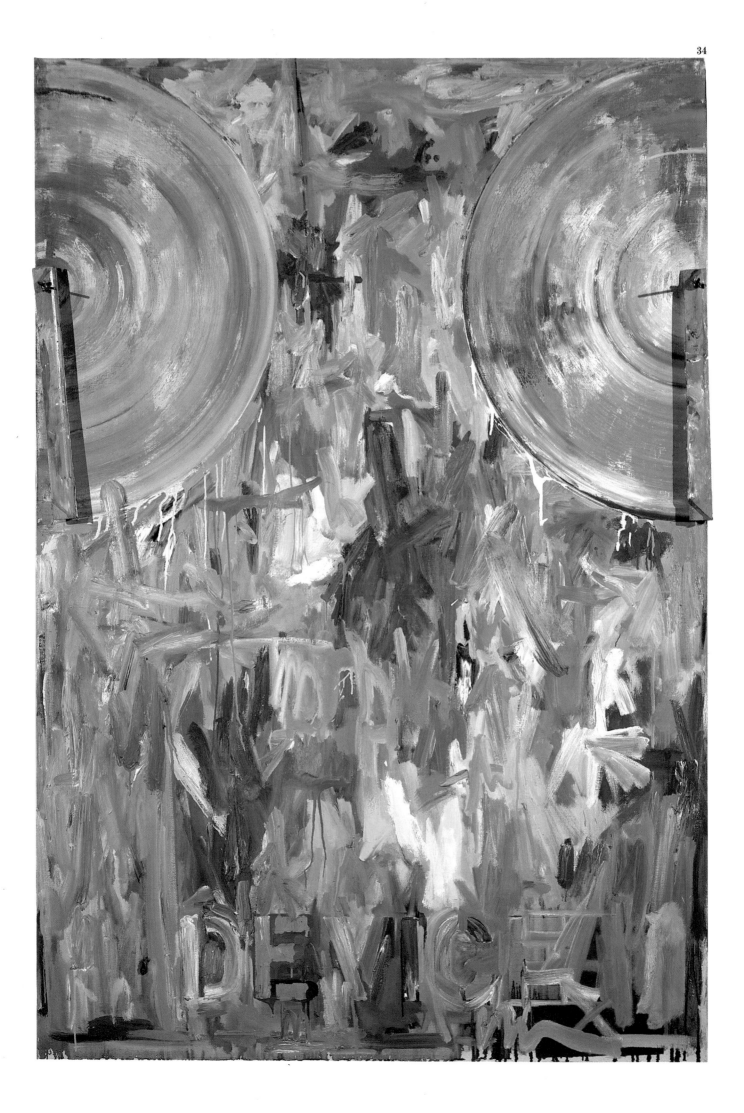

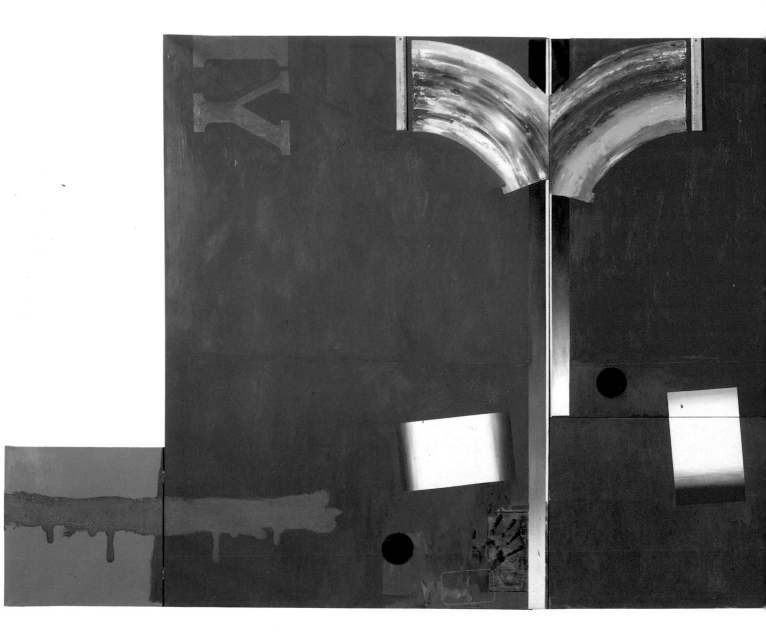

35 Untitled, *1964–1965. This triptych is once again based on Johns's three signature colors, here rendered as uniform surfaces. As usual, the letters allude to those colors, albeit in a fragmentary manner. The rainbow arrows indicate tension points and, like hinges, they highlight the division between the three sections. The broom at the far right parodies the artist's often-used device of a swinging paintbrush, whose movement has left a faint white arc underneath.*

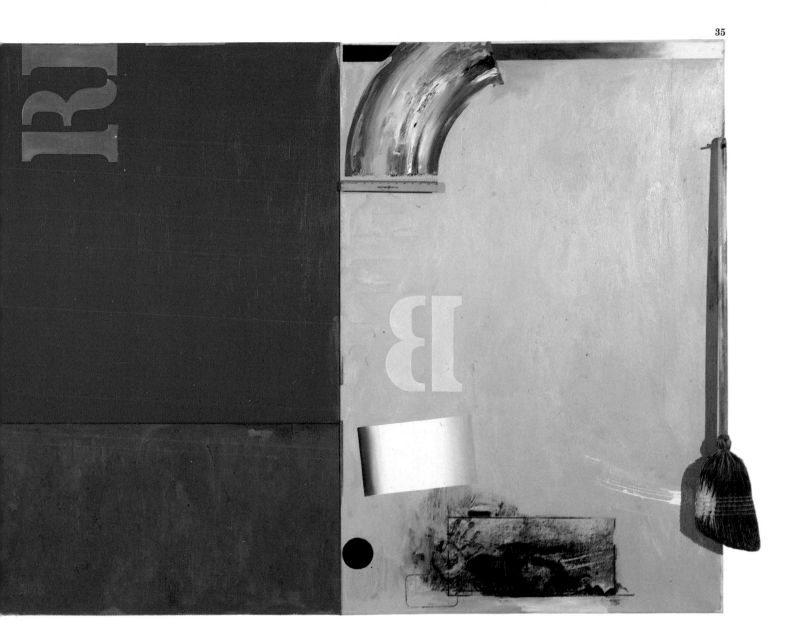

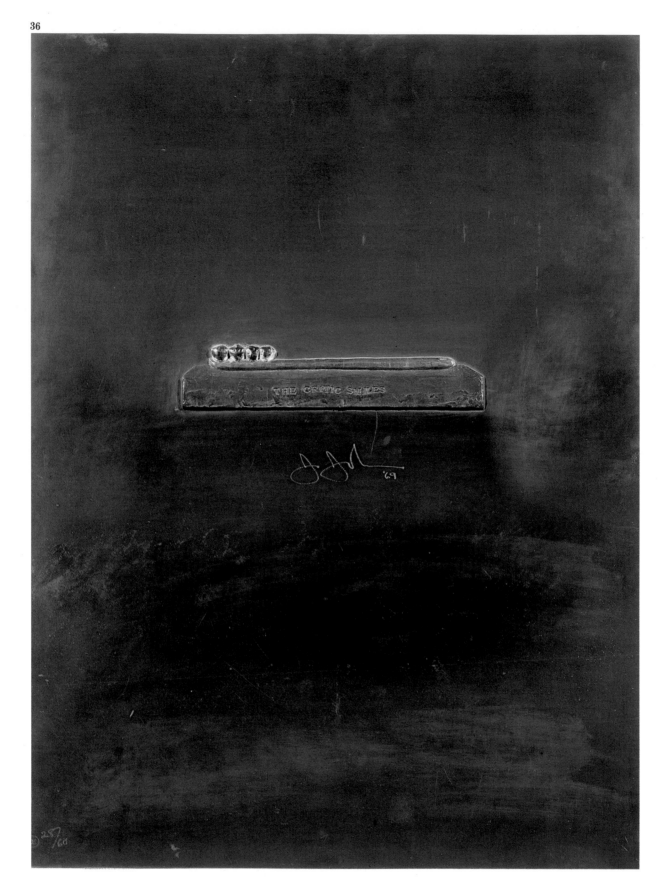

36 The Critic Smiles, *1969. The transformation of the toothbrush bristles into teeth introduces a humorous joke on art criticism, halfway between Dadaism and Pop art. Richard Hamilton, one of the pioneers of Pop art in Britain, conceived a similarly-spirited mobile, in which an electrical vibrator activated a set of dentures that burst out laughing.*

37 In the Workshop, *1982. The background suggests a wall of the painter's studio on which hang two pairs of images linked by strange parallelisms: on one side, the painted plaster cast of an arm and its plane image, while on the other side we see a crosshatching and, underneath, its smudged version as a dripping. The actual relief of the plaster cast and the wood board contrasts with the trompe l'oeil nails that secure the sheets to the wall.*

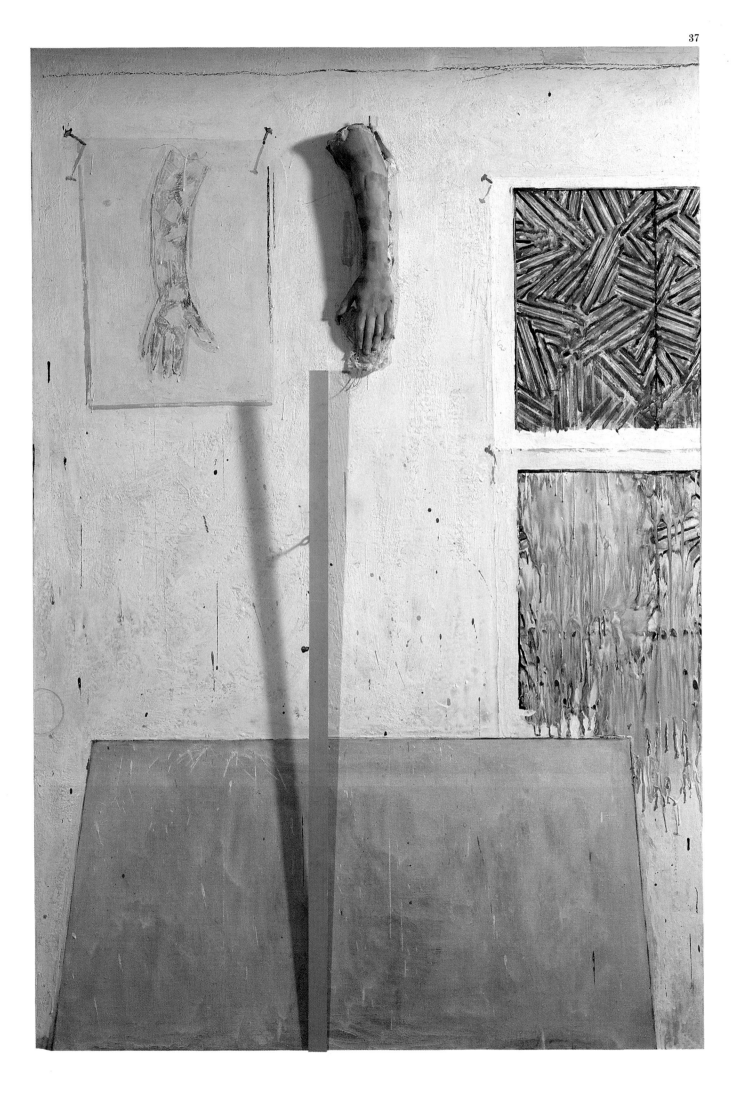

38

Activated Surfaces

The underlying basis of Jasper Johns's painting has always been the inter-action of pictorial matter and color over a surface. This idiom does not always rest on such pre-existent iconic structures as targets and flags; at times, it flows autonomously, with no objective referent or figurative allu-sion. Although examples of this are to be found even among Johns's earli-er works, it was in 1967 with flagstones, and above all in 1972 with crosshatchings, that the painter developed this vein to its full extent. Hav-ing reclaimed the object for painting, the artist apparently felt the need to revise the contributions of the preceding generation of Abstract Expres-sionist painters that had focused on the possibilities of painterly gestures over a large surface with purely arbitrary boundaries, a so-called "all-over field." Linear patterns and color mosaics afforded Johns a scheme to match his ambitions, and to marginalize the conceptual discourse over the object more typical of his early works.

38 Tango, *1955. Contemporary to his early flags, this is one of the first paintings that Johns left devoid of any referential image, in order to directly confront a color surface modulated and textured in assorted shades of blue.*

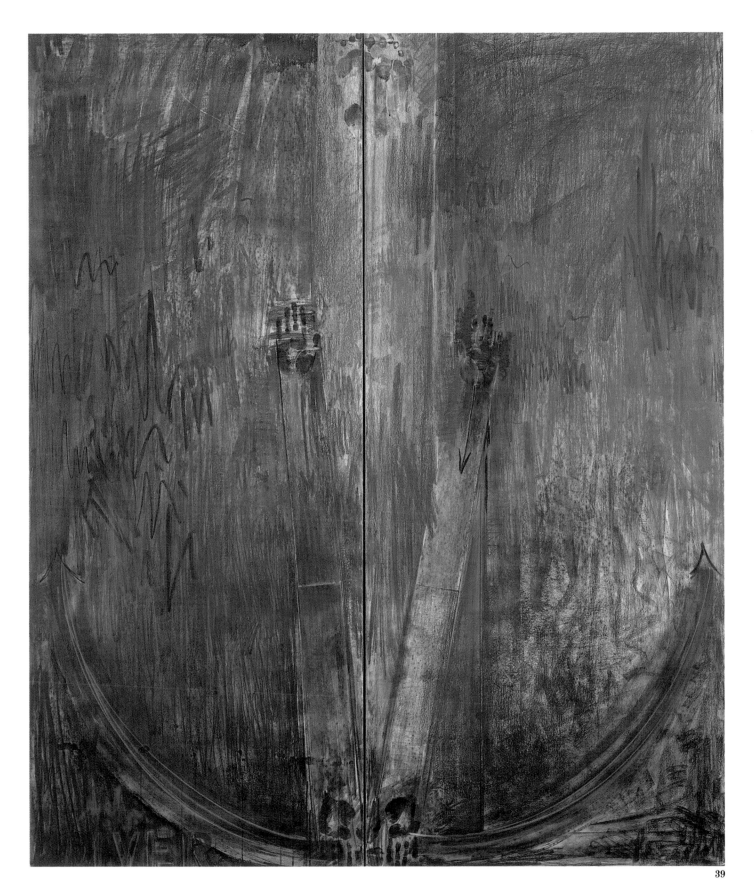

39 Diver, *1963. In the early 1960s Johns painted several works on this theme. The
diver, schematically represented by elongated rectangles, handprints, and footprints,
is getting ready to dive into the pool. The vigorous circular movement suggested by the
arrows activates the surface, which is covered with brisk lines drawn in charcoal and
pastel.*

40 Harlem Light, *1967. This is the first appearance of flagstones, which the painter adopted from a pattern painted on a wall that he had seen while driving through Harlem. They cover most of the left half of the painting, whose remaining parts comprise several superimposed skewed planes. The theme of the painting is the joint and separate readings of these various structures. It is thus akin to such works as* According to What *(no. 32). Johns's signature red, yellow, and blue sequence, spelled out in the three squares at the center, is subtly present throughout the composition.*

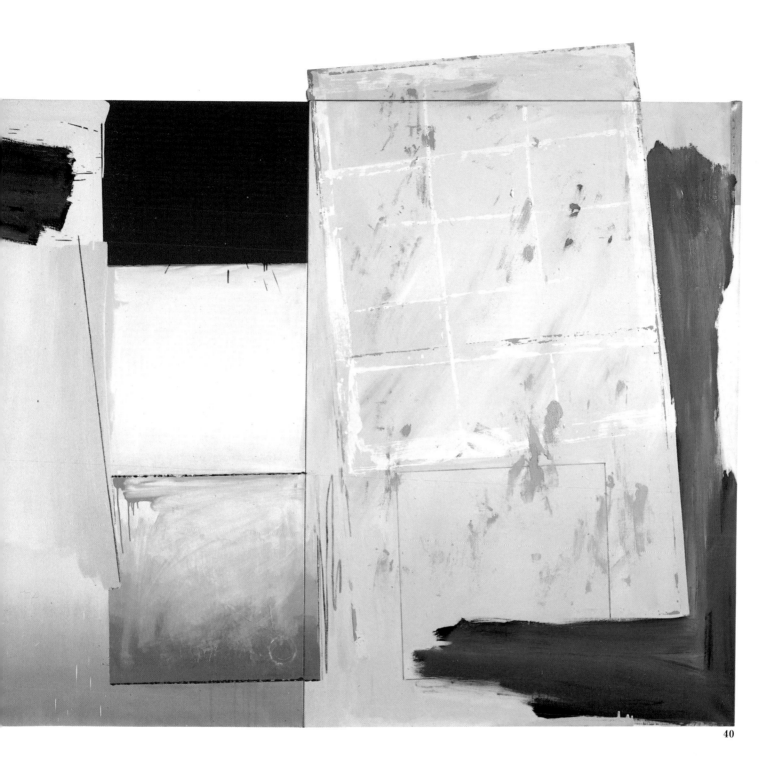

40

41 Tearful Women, *1975. This instance of crosshatchings in triptych form is a reworking of the three* Crying Women *that Picasso painted in 1937 in the same tonality as each one of Johns's panels. The varnish-like use of the white strokes and the interweaving patterns endows the canvas with a certain spatial depth.*

42 The Hairdresser's Tree, *1975. The title alludes to the motif from which Johns drew inspiration for his crosshatchings, an ad for a Mexican hairdresser painted on a tree, in which two color bands were tied in a bow.*

43 Usuyuki, *1977–1978. The varying brightness of the thick white strokes is reminiscent of the paintings of Mark Tobey, an Abstract Expressionist who was profoundly influenced by Japanese culture.*

41

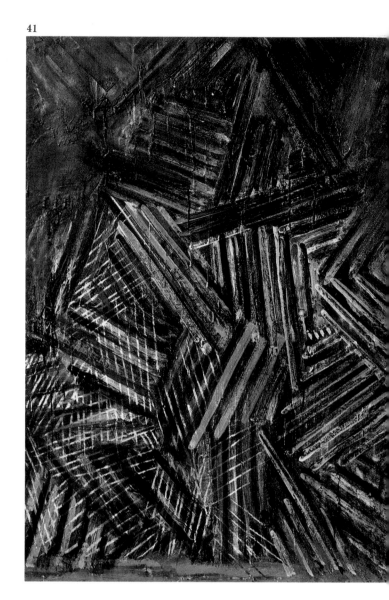

42

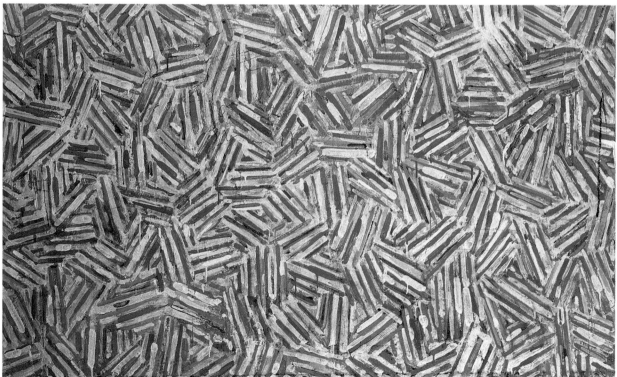

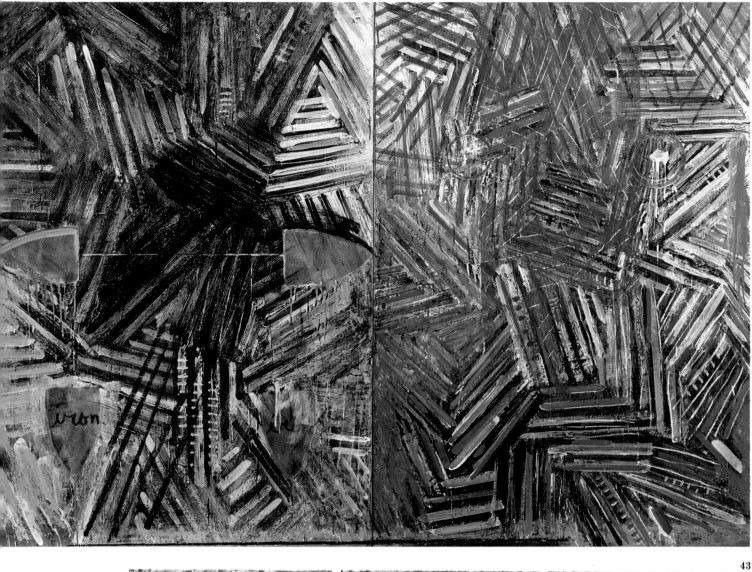

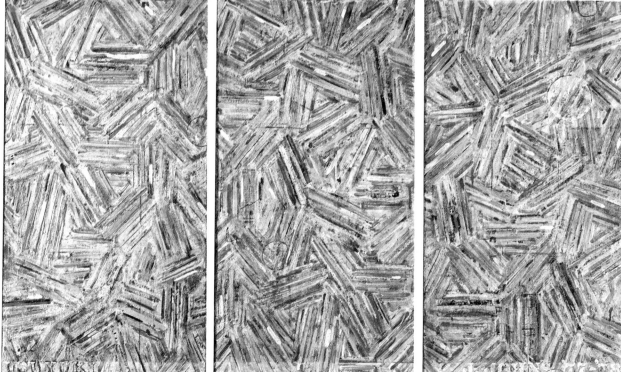

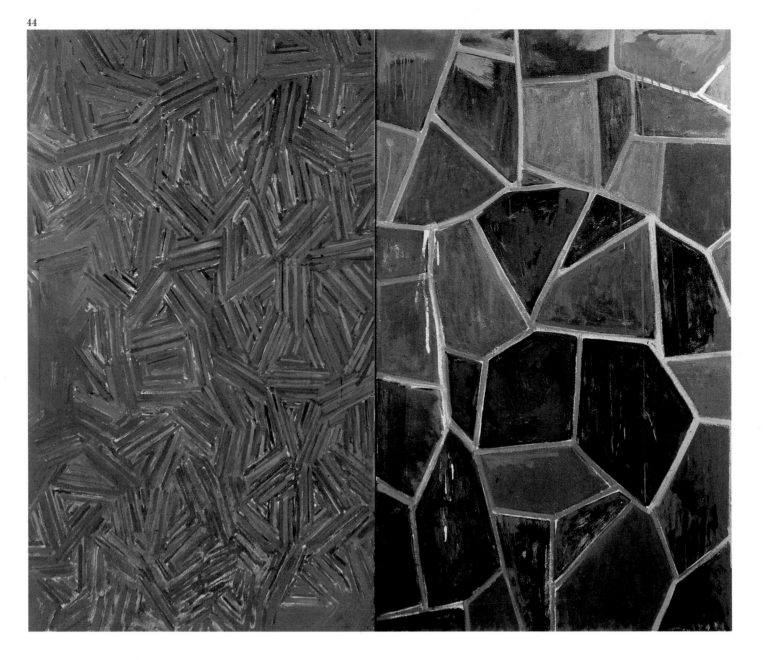

44 Flyleaves, *1976. The title suggests a connection between two panels, one covered with crosshatchings and another with flagstones, to the watermarks that are sometimes found on flyleaves. Even in compositions such as this, which are completely alien to the representation of the objective world, Johns does not forgo a reference to the viewer's visual experience.*

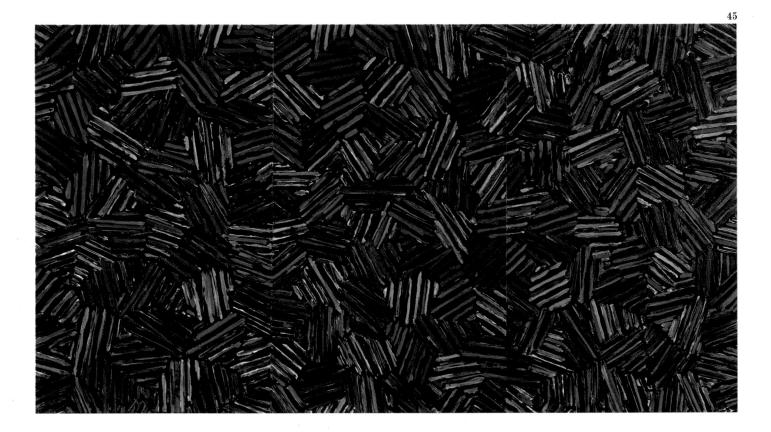

45, 46 Untitled, *1980.* Untitled, *1980. In some instances, Johns's crosshatchings can be viewed as a restrained modification of the drippings typical of the Abstract Expressionists. No doubt the concept governing the pictorial surface is the same; Johns, however, marshals his painterly gestures so that his color generates luminous effects.*

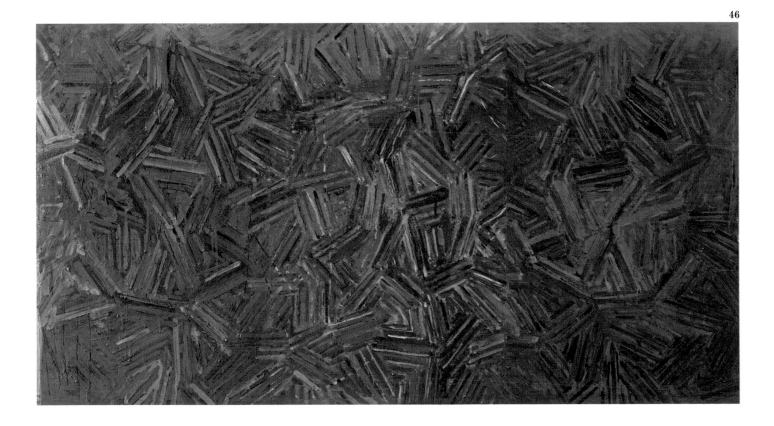

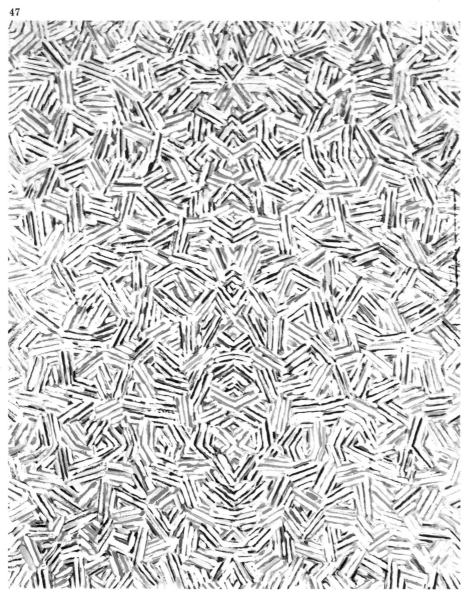

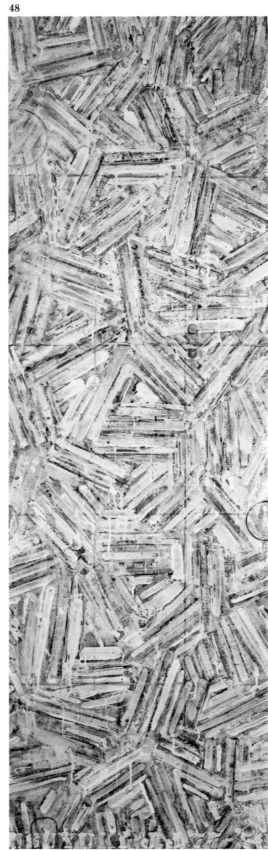

47, 48 Dancers in an Airplane, *1982*. Usuyuki, *1977–1978. At times, as in the first of these paintings, the interweaving patterns on the pictorial surface evoke movements related to the title. Such an association of rhythm and color is reminiscent of Mondrian's late painting,* Broadway Boogie Woogie.

49, 50, 51 Between the Clock and the Bed, *1981*. Between the Clock and the Bed, *1981*. Between the Clock and the Bed, *1982–1983. Three variations on a theme inspired by a late work that Edvard Munch painted in 1940–1942. The patterns of the crosshatching betray a reference to the three elements of Munch's original: a grandfather clock on the left, a standing human figure in the middle, and a bed with a patterned Lappish bedspread in the lower right corner.*

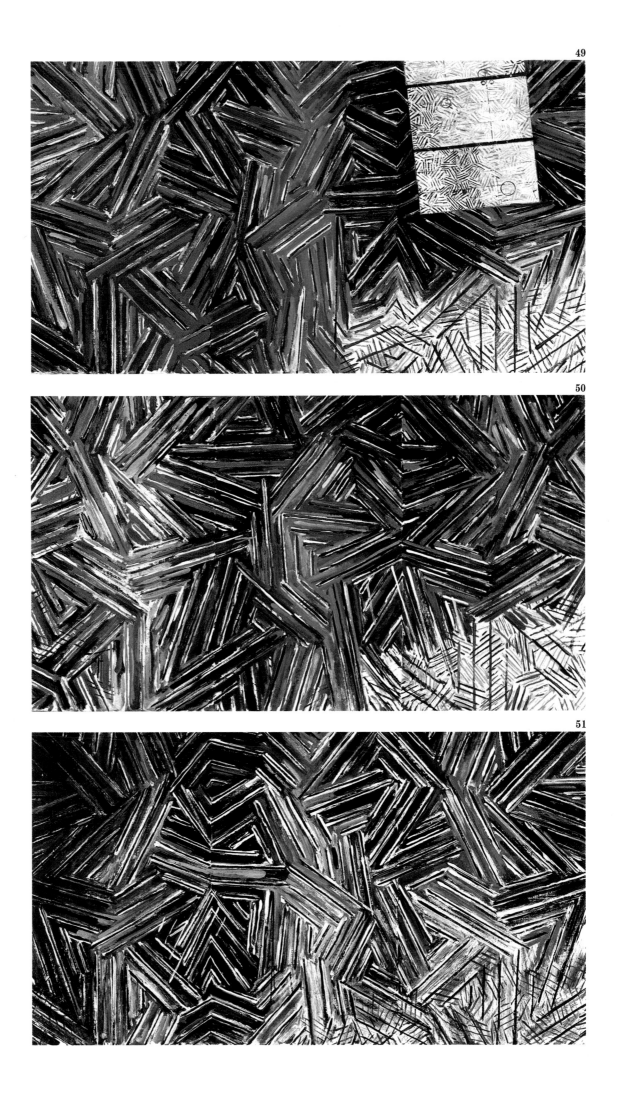

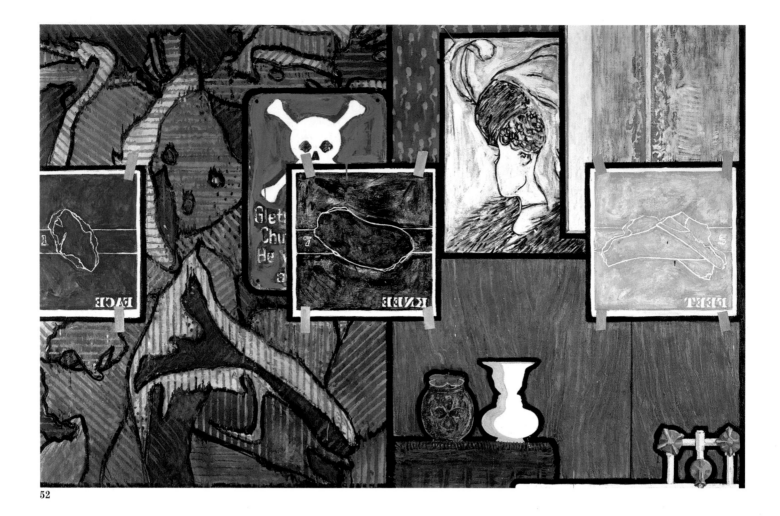

52

Painting, Sign, and Image

The works that Johns painted in the 1980s summarize all the problems that he had tackled earlier in his career, and they also bring his early work face to face with painting from previous ages. The works of the decade all seem to revolve around the *Four Seasons*, four large paintings shown at the 1988 Venice Biennale that constitute Johns's version of the classic cycle of the stages of life. The four canvases are dominated by the artist's silhouette, around which gravitate clusters of images that allude to Johns's own work (crosshatchings, flags), to famous paintings (*Mona Lisa*, Grünewald's Isenheim altarpiece), and to a number of objects related to the painter himself. Indeed, the most striking feature of these works is the unprecedented personal involvement of the artist, elsewhere so protective of his privacy. Johns himself pointed this out when he noted that in his earlier works he had always deliberately avoided any personal projection. "This was partly due to how I felt about painting in those years. For some time, I tried not to waver in my resolve, but later, I realized that it was a lost battle. Eventually, one has to lower one's guard. I believe that certain changes in my work may indeed be related to this fact."

52 Untitled, *1984. Although this work is painted throughout, it represents a collagelike arrangement of images: what appear to be radiographs of a foot, a knee, and a face, with their respective labels written backwards; a portrait by Toulouse-Lautrec; and a "danger" sign warning of ice falling from a glacier.*

53 Ventriloquist, *1983. This painting displays a number of autobiographical references, for example, the double flag, portrayed as a printed reproduction hanging on the wall, and pieces from Johns's collection of early twentieth-century pottery by Georg Ohr.*

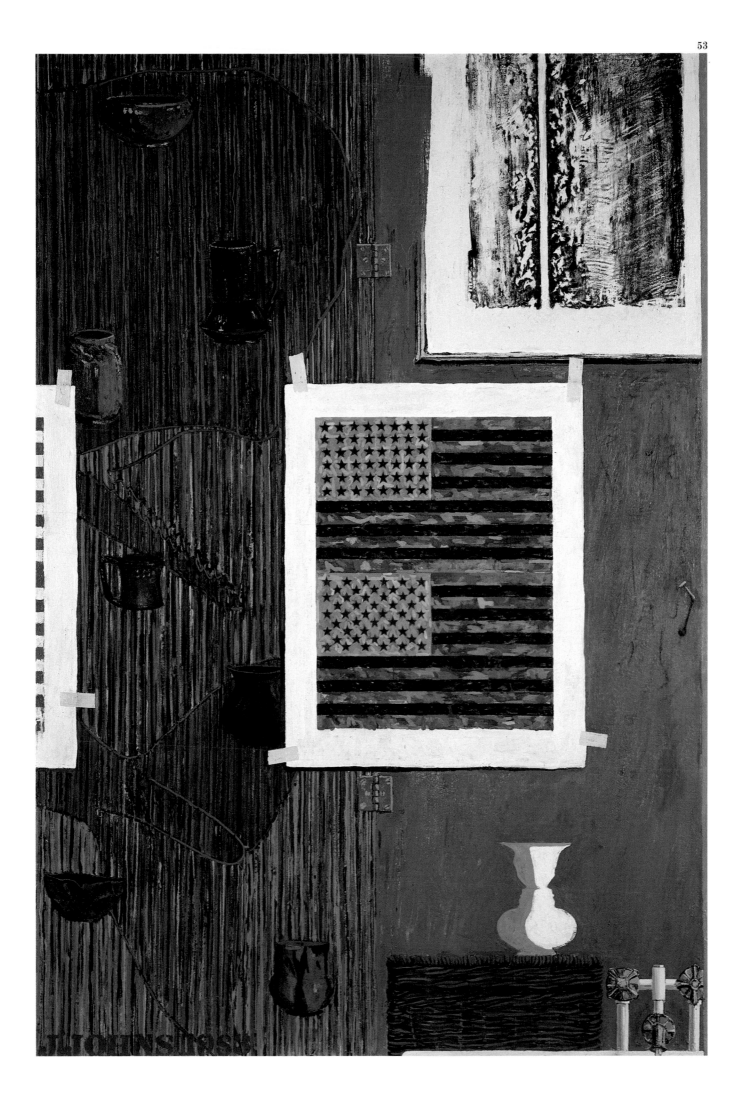

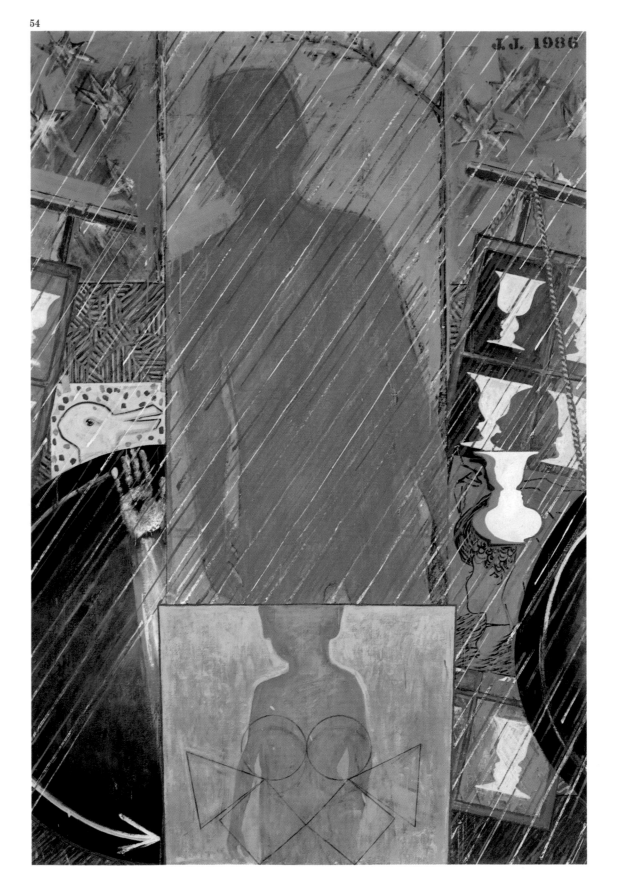

54 Spring, *1986. Although this painting begins the* Four Seasons *series, Johns did not paint it first. The artist's silhouette, traced by his friend Julian Lethbridge, occupies the central band, its lower portion partially overlapped by the silhouette of a child. The hand inscribed in the circle extending from behind the silhouettes represents a clock that marks the time in this peculiar cycle. The outlines of the goblets describe the profiles of faces set in various expressions; the one vase standing slightly in front of the others demarcates those of Queen Elizabeth II and Prince Philip, Duke of Edinburgh.*

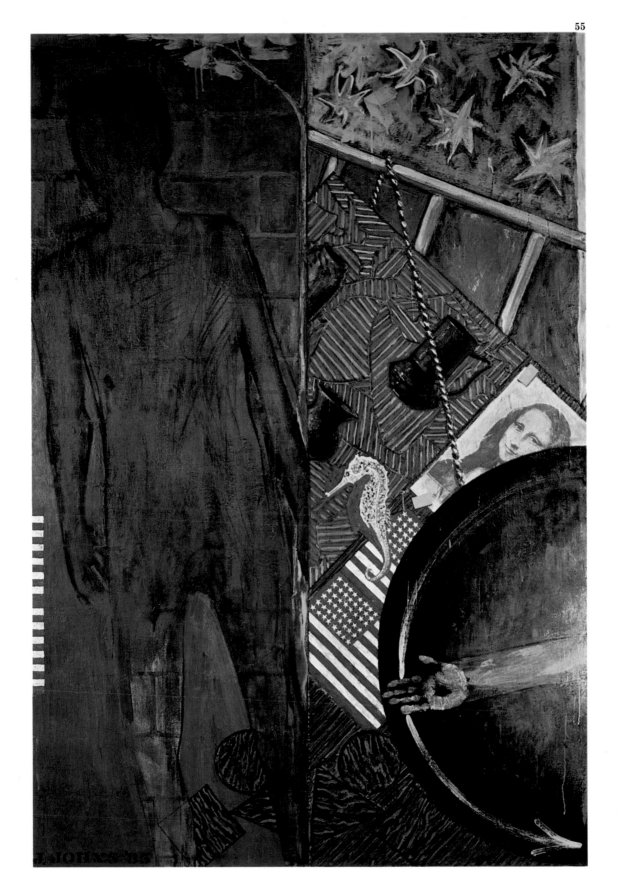

55 Summer, *1985. This was the first of the* Four Seasons *series that Johns actually painted. The hand of the clock is now halfway through its course, while the arrow points in a counterclockwise direction. The position and the implied movement of the artist's silhouette on the left suggest a reading of the composition from right to left. Ohr's pottery and the flags are autobiographical references, as is the* Mona Lisa, *a gesture of homage to Marcel Duchamp.*

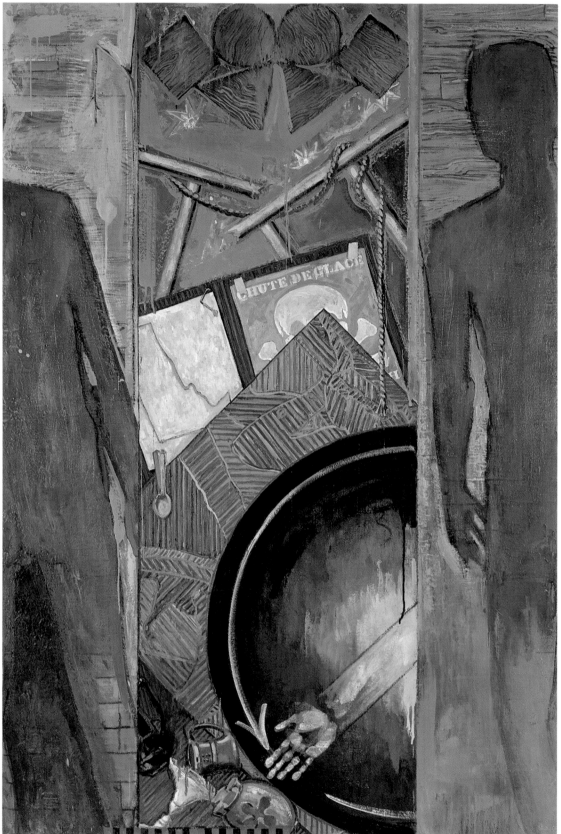

57 Winter, *1986. The hand of the clock now points straight downward; the snow and the coldness of the blue tonality are in keeping with the thematic season. More than in any other painting of this series, the blocks of the wall can be read through the artist's spectral silhouette. The squares, triangles, and spheres, which in the other three canvases are arbitrarily suspended, are now neatly lined up and motionless. Like the torch of the angel of death in a classical allegory, Ohr's inverted vases suggest approaching doom.*

56 Autumn, *1986. The hand of the clock is now moving downward, seemingly pushed by the arrow. The elements in the central band have collapsed, as if in some catastrophic event. The enigmatic symbolism of the series is less ambiguous here than in the other three compositions; at the time of this painting, Johns was fifty-six, and in the autumn of his life, moving toward some distant place, as suggested by the duplication of the silhouette.*

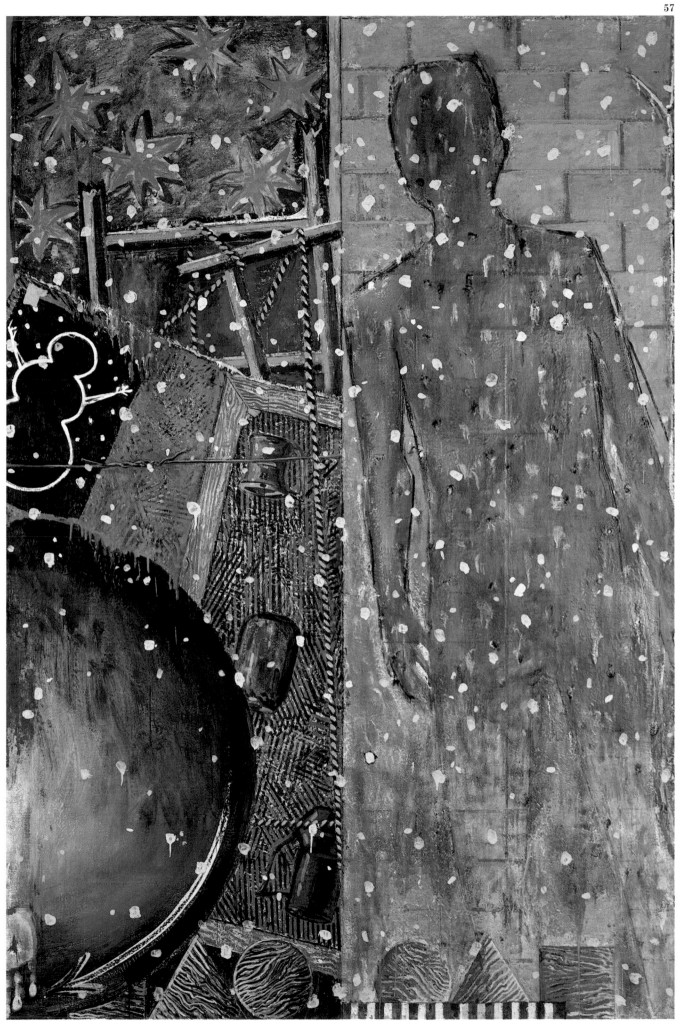

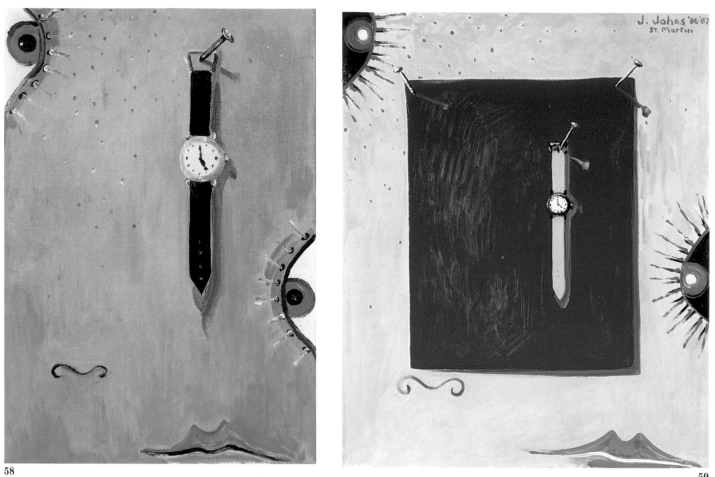

58 59

58, 59 Untitled, *1986. Untitled, 1986–1987. The mouth in the lower right corner and the eyes flush to the edge justify a reading of each of these paintings as an enigmatic face, while the central presence of the watch relates them to the* Four Seasons.

60 Racing Thoughts, *1984. The symbolic imagery of this work foreshadows that of the* Four Seasons. *Here, too, is the emblematic* Mona Lisa, *and the skull and crossed bones above the German phrase* "Gletscherabbruch" *and the French* "Chute de glace"—*both of which warn of ice falling from a glacier—and the English* "Be Ware" *(sic).*

60

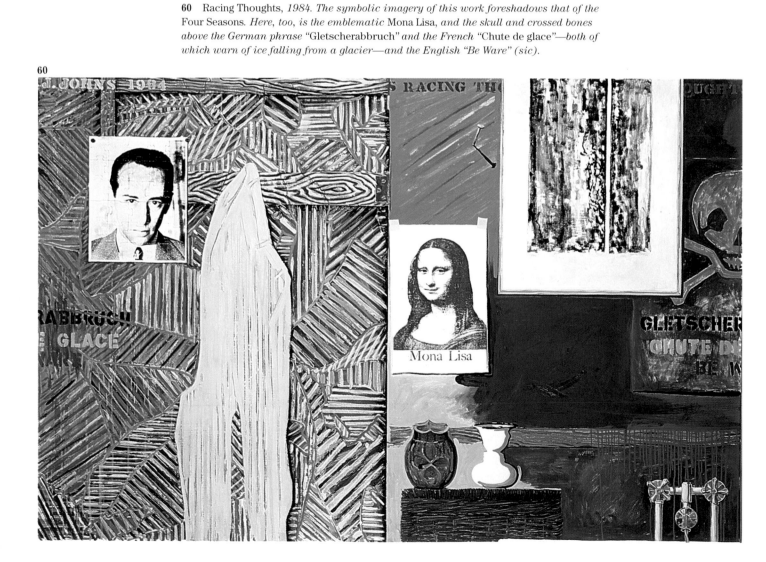

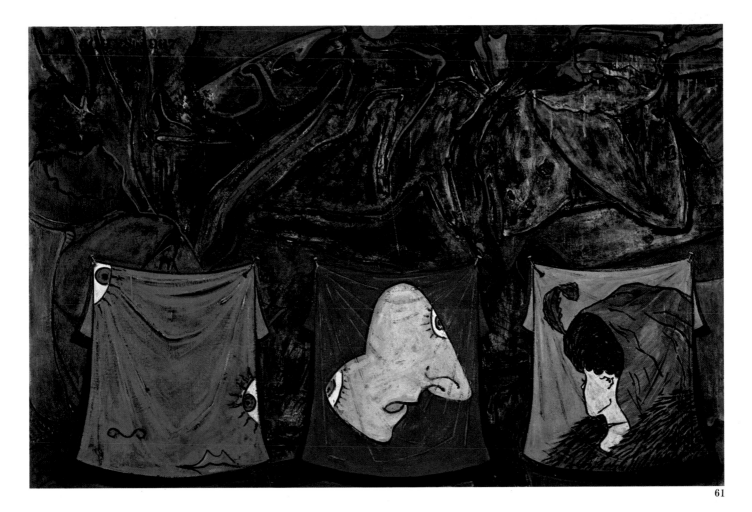

61

61, 62 Untitled, *1987*. Untitled, *1987. Both paintings are related, in the canvas on the left, to the two enigmatic faces with watches of 1986–1987 (nos. 58 and 59). Using a painting by Toulouse-Lautrec as his starting point, Johns arrives at an enigmatic allegory of the passage of time.*

62

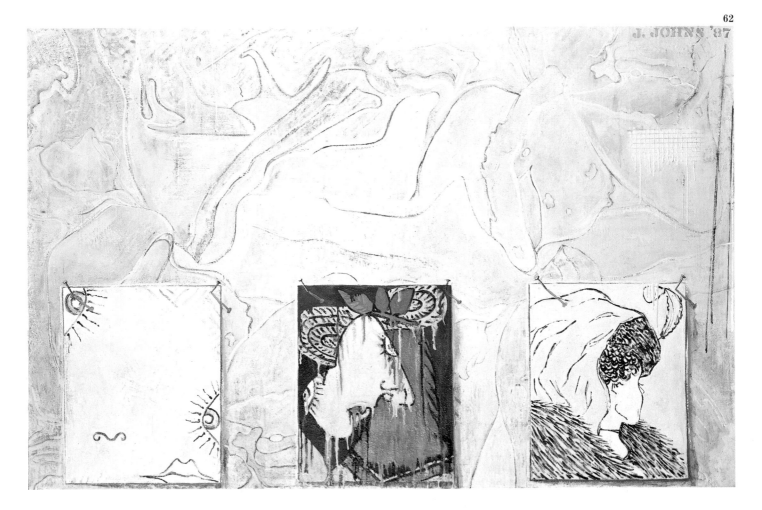

63 Untitled, *1984. As in* Racing Thoughts *(no. 60), here again two iconographic elements prefigure those of the* Four Seasons: *the background pattern, which reproduces a detail of a motif by Grünewald, and the image on the right, derived from Toulouse-Lautrec.*

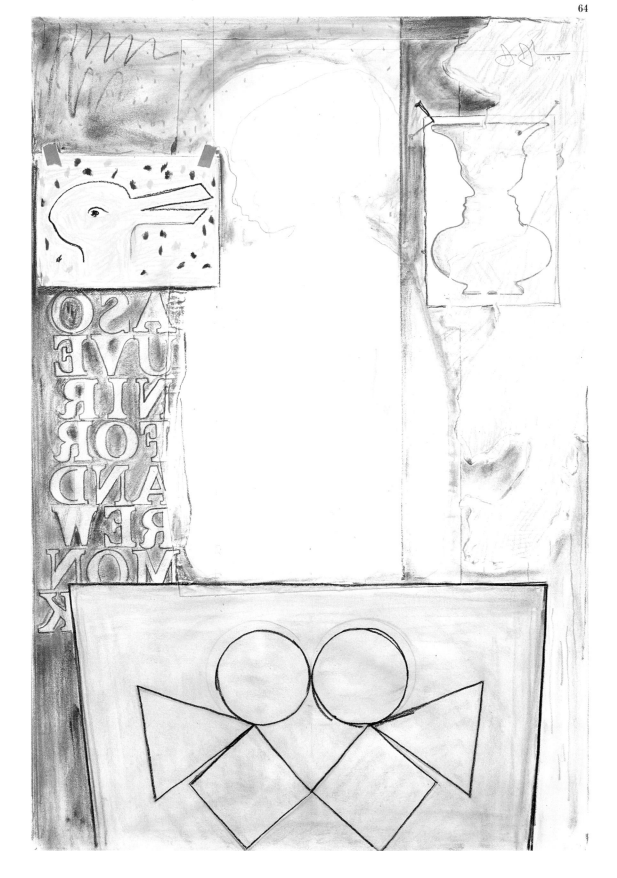

64 A Souvenir for Andrew Monk *1987. This painting, derived from the* Four Seasons, *which culminates the artist's production of the 1980s, is organized around the figure of a child. Once again, we find the motif of the vase with the facing profiles of Queen Elizabeth II and Prince Philip, and a group of geometric figures. It should be noted that the title is printed in reverse, as if seen from behind a glass, possibly a reference to Duchamp's* Large Window.

List of Plates

1 Flag, *1954–1955; dated on reverse 1954. Encaustic, oil, and collage on fabric mounted on plywood, 42¼ × 60⅝" (107.3 × 153.8 cm). The Museum of Modern Art, New York. Gift of Philip Johnson in honor of Alfred H. Barr, Jr. Photograph © 1996 The Museum of Modern Art, New York*

2 Green Target, *1955. Encaustic on newsprint over canvas, 60 × 60" (152.4 × 152.4 cm). The Museum of Modern Art, New York. Richard S. Zeisler Fund. Photograph © 1996 The Museum of Modern Art, New York*

3 White Flag, *1955. Encaustic and collage on canvas, 78 × 119⁵⁄₁₆" (198 × 303 cm). Collection of the artist*

4 Target with Four Faces, *1955. Assemblage: encaustic and collage on canvas with objects, 26 × 26" (66 × 66 cm) surmounted by four tinted plaster faces in wood box with hinged front. Box, closed, 3¾ × 26 × 3½" (9.5 × 66 × 8.9 cm). Overall dimensions with box open, 33⅜ × 26 × 3" (85.3 × 66 × 7.6 cm). The Museum of Modern Art, New York. Gift of Mr. and Mrs. Robert C. Scull. Photograph © 1996 The Museum of Modern Art, New York*

5 Target with Plaster Casts, *1955. Encaustic and collage on canvas, and plaster casts, 51 × 44 × 3½" (129.5 × 111.7 × 9 cm). Collection Leo Castelli*

6 Two Flags, *1959. Plastic paint on canvas, 79⅛ × 58¼" (201 × 148 cm). Private collection*

7 Target, *1974. Encaustic and collage on canvas, 61¼ × 53⅜" (155.5 × 135.5 cm). The Seibu Museum of Art, Tokyo*

8 Map, *1961. Oil on canvas, 6'6" × 10'3⅛" (198.2 × 314.7 cm). The Museum of Modern Art, New York. Gift of Mr. and Mrs. Robert C. Scull, 1963. Photograph © 1996 The Museum of Modern Art, New York*

9 Three Flags, *1958. Encaustic on canvas, 30⅛ × 45⅝ × 5" (76.5 × 116 × 12.7 cm). The Whitney Museum of American Art*

10 Map, *1963. Encaustic and collage on canvas, 60 × 92⅞" (152.5 × 236 cm). Private collection*

11 Flag against an Orange Background, *1957. Encaustic on canvas, 66 × 49" (167.6 × 124.5 cm). Museum Ludwig, Cologne*

12 Flag, *1960–1961. Encaustic on paper over canvas, 17½ × 26¾" (44.5 × 68 cm). Collection Michael Crichton*

13 0–9, *1959. Encaustic and collage on canvas, 20⅛ × 35" (51 × 89 cm). Ludwig Collection*

14 False Start, *1959. Oil on canvas, 67¼ × 53⅞" (171 × 137 cm). Collection Mr. and Mrs. S. I. Newhouse, Jr., New York*

15 Color Numbers, *1958–1959. Encaustic and collage on canvas, 67 × 49½" (170 × 126 cm). Albright-Knox Art Gallery, Buffalo*

16 Digit 0, *1959. Encaustic on canvas, 20¼ × 15⅛" (51.5 × 38.5 cm). Private collection*

17 Digit 2, *1962. Encaustic and collage on canvas, 51¾ × 41½" (130.5 × 105.5 cm). Öffentliche Kunstsammlung, Basel Kunstmuseum*

18 Alphabets, *1962. Oil on paper over canvas, 34 × 24" (86.3 × 61 cm). Private collection*

19 Zero through Nine, *1961. Oil and charcoal on canvas, 54 × 41⅛" (137 × 104.5 cm). Private collection, Connecticut*

20 0 through 9, *1961. Oil and charcoal on canvas, 54 × 41¼" (137.3 × 104.9 cm). Hirshhorn Museum and Sculpture Garden, Washington, D.C.*

21 The End of the World, *1963. Oil on canvas and board, 67 × 48¼" (170.2 × 122.5 cm). San Francisco Museum of Modern Art (gift of Mr. and Mrs. Harry W. Anderson)*

22 Slow Field, *1962. Oil on canvas and objects, 71¼ × 35½" (181 × 90 cm). Moderna Museet, Stockholm*

23 Voice 2, *1971. Oil and collage on canvas, three panels, each 72 × 50" (183 × 127 cm). Öffentliche Kunstsammlung, Basel Kunstmuseum*

24 Fragments—According to What—Inverted "Blue," *1971. Color lithograph with transfers, second state, 25½ × 28¾" (64.8 × 73 cm). Edition of 66. Printer: Gemini G. E. I., Los Angeles*

25 Zero through 9, *1961. Sculpted metal, 27 × 21" (68.5 × 53.3 cm). Edition of 4. Collection of the artist*

26 Numbers, *1963–1978. Aluminum relief, 57½ × 43½" (146 × 110.5 cm). Collection of the artist*

27 Painted Bronze, *1960. Painted bronze, 5½ × 9 × 4¾" (14 × 20.3 × 12.1 cm). Öffentliche Kunstsammlung, Basel Kunstmuseum (Collection Ludwig-Saint-Alban)*

28 Painting with Two Balls, *1960. Encaustic and collage on canvas and objects, 65 × 54" (165.1 × 137.2 cm). Collection of the artist*

29 Eddingsville, *1965. Oil on canvas and objects, 68 × 122½" (172.7 × 311.2 cm). Museum Ludwig, Cologne*

30 M, *1962. Oil on canvas and objects, 36 × 24" (91.5 × 61 cm). The Seibu Museum of Art, Tokyo*

31 Painted Background, *1963–1964. Oil on canvas and objects, 72 × 36⅝" (183 × 93 cm). Collection of the artist*

32 According to What, *1964. Oil on canvas and objects, 88 × 192" (223.5 × 487.5 cm). Collection Mr. and Mrs. S. I. Newhouse, Jr., New York*

33 Zone, *1962. Oil, encaustic, and collage on canvas and objects, 60 × 36" (153 × 91.5 cm). Kunsthaus, Zurich*

34 Device, *1961–1962. Oil on canvas and objects, 72 × 48¼ × 4½" (182.9 × 122.5 × 11.4 cm). Dallas Museum of Fine Arts*

35 Untitled, *1964–1965. Oil on canvas and objects, 72 × 168" (182.9 × 426.7 cm). Stedelijk Museum, Amsterdam*

36 The Critic Smiles, *1969. Lead relief with tin foil and molten gold, 23 × 17" (58.4 × 43.2 cm). Edition of 60*

37 In the Workshop, *1982. Encaustic on canvas and objects, 72 × 48 × 4" (183 × 122 × 10 cm). Collection of the artist*

38 Tango, *1955. Encaustic and collage on canvas and objects, 43 × 55" (109.2 × 137.9 cm). Private collection*

39 Diver, *1963. Charcoal and pastel on paper, 86½ × 71" (219.7 × 180.3 cm). Collection Mrs. Victor W. Ganz*

40 Harlem Light, *1967. Oil on canvas and collage, 78 × 172" (198.1 × 436.9 cm). Collection David Whitney*

41 Tearful Women, *1975. Encaustic and collage on canvas, 50 × 102⅜" (127 × 260 cm). Collection Mr. and Mrs. S. I. Newhouse, Jr., New York*

42 The Hairdresser's Tree, *1975. Encaustic on canvas, 34¼ × 54⅜" (87 × 138 cm). Neue Galerie, Aachen (Ludwig collection)*

43 Usuyuki, *1977–1978. Encaustic and collage on canvas, three panels, 35 × 56½" (89 × 143.5 cm). Collection of the artist*

44 Flyleaves, *1976. Oil on canvas, two panels, 60 × 69½" (152.5 × 176.5 cm). Collection David Whitney*

45 Untitled, *1980. Acrylic on plastic over canvas, 30¼ × 54¼" (77 × 138 cm). Gagosian Gallery, New York*

46 Untitled, *1980. Encaustic and collage on canvas, 30 × 54" (76.2 × 137 cm). Collection Raymond Nasher, Dallas*

47 Dancers in an Airplane, *1982. Oil on canvas, 29⅞ × 23⅜" (76 × 60 cm). Collection of the artist*

48 Usuyuki, *1977–1978. Encaustic and collage on canvas, 56¼ × 18" (144 × 45.7 cm). Private collection*

49 Between the Clock and the Bed, *1981. Oil on canvas, three panels, 72 × 126⅜" (183 × 321 cm). Collection of the artist*

50 Between the Clock and the Bed, *1981. Encaustic on canvas, three panels, overall, 6'1⅛" × 10'6⅜" (183.4 × 302.2 cm). The Museum of Modern Art, New York. Gift of Agnes Gund. Photograph © 1996 The Museum of Modern Art, New York*

51 Between the Clock and the Bed, *1982–1983. Oil on canvas, three panels, 72 × 126⅜" (183 × 321 cm). Virginia Museum of Fine Arts, Richmond (gift of the Sydney and Frances Lewis Foundation)*

52 Untitled, *1984. Encaustic on canvas, 50 × 75" (127 × 190.5 cm). Collection of the artist*

53 Ventriloquist, *1983. Encaustic on canvas, 75 × 50" (190.5 × 127 cm). The Museum of Fine Arts, Houston (purchase: Agnes Cullen Endowment Fund)*

54 Spring, *1986. Encaustic on canvas, 75 × 50" (190.5 × 127 cm). Collection Mr. and Mrs. S. I. Newhouse, Jr., New York*

55 Summer, *1985. Encaustic on canvas, 75 × 50" (190.5 × 127 cm). Collection Philip Johnson*

56 Autumn, *1986. Encaustic on canvas, 75 × 50" (190.5 × 127 cm). Collection of the artist*

57 Winter, *1986. Encaustic on canvas, 75 × 50" (190.5 × 127 cm). Collection Mr. and Mrs. Asher B. Edelman, New York*

58 Untitled, *1986. Oil on canvas, 17¼ × 11⅝" (44 × 29.5 cm). Collection of the artist*

59 Untitled, *1986–1987. Oil on canvas, 32 × 25½" (81.2 × 65 cm). Collection of the artist*

60 Racing Thoughts, *1984. Oil on canvas, 50 × 75" (127 × 190.5 cm). Collection Robert and Jane Meyerhoff, Phoenix, Maryland*

61 Untitled, *1987. Encaustic and collage on canvas, 50 × 75" (127 × 190.5 cm). Collection Robert and Jane Meyerhoff, Phoenix, Maryland*

62 Untitled, *1987. Encaustic on canvas, 50 × 75" (127 × 190.5 cm). Hirshhorn Museum and Sculpture Garden, Washington, D.C.*

63 Untitled, *1984. Oil on canvas, 75 × 50" (190.5 × 127 cm). Private collection*

64 A Souvenir for Andrew Monk, *1987. Chalk, charcoal, graphite, and collage on paper, 41⅞ × 28" (106.5 × 71 cm). Collection of the artist*

Recommended Bibliography

George Boudaille, *Jasper Johns*, Ediciones Polígrafa, Barcelona, 1989

Judith Goldman, *Jasper Johns*, Les Saisons, catalog, Leo Castelli Gallery, New York, 1987

Riva Castleman, *Jasper Johns, l'oeuvre gravé*, Schirmer et Mosel, Munich, 1986

Marcelin Pleynet, *Les Etats Unis de la peinture*, Le Seuil, Paris, 1986

Michael Crichton, *Jasper Johns*, Harry N. Abrams, New York, 1977

Series Coordinator, English-language edition: Ellen Rosefsky Cohen
Editor, English-language edition: Elaine Stainton
Designer, English-language edition: Judith Michael

Library of Congress Catalog Card Number: 96–84009
ISBN 0–8109–4683–1

Published in 1996 by Harry N. Abrams, Incorporated, New York
A Times Mirror Company

Printed and bound in Spain by La Polígrafa, S.L.
Parets del Vallès (Barcelona)
Dep. Leg.: B.11578–1996